THE ELEMENTS OF
SYMBOLIS

John Baldock is a teacher an
has recently given a series of illustrated talks on
Christian symbolism in the United States, Germany
and Switzerland.

The *Elements Of* is a series designed to present high quality introductions to a broad range of essential subjects.

The books are commissioned specifically from experts in their fields. They provide readable and often unique views of the various topics covered, and are therefore of interest both to those who have some knowledge of the subject, as well as those who are approaching it for the first time.

Many of these concise yet comprehensive books have practical suggestions and exercises which allow personal experience as well as theoretical understanding, and offer a valuable source of information on many important themes.

THE ELEMENTS OF

CHRISTIAN
SYMBOLISM

John Baldock

ELEMENT BOOKS

First published in Great Britain in 1990 by
Element Books Limited
Longmead, Shaftesbury, Dorset

Cover Illustration Celtic Reliquary (detail) National Museum
of Ireland, Dublin
Cover design by Max Fairbrother
Illustrations by John Baldock
Typeset by Selectmove Ltd, London
Printed and bound in Great Britain by
Billings Ltd, Hylton Road, Worcester

British Library Cataloguing in Publication Data
Baldock, John
The elements of Christian symbolism.
1. Christian church. Symbolism
I. Title
246.55

ISBN 1–85230–175–9

CONTENTS

To my Mother

ACKNOWLEDGEMENTS

I should like to express my gratitude to all those who have contributed directly or indirectly towards the writing of this book. In particular I am grateful to the following friends for their assistance and the valuable part they played in its creation: to Dr. Reshad Feild who acted as the catalyst; to the Reverend Peter Dewey for his valuable help and ideas; to Michael Mann for his help and encouragement throughout its writing; and especially to Christa Grasser, without whom it would probably never have been written.

INTRODUCTION

The universal nature of Christianity and the wealth of symbolism that permeates it on all levels has meant that Christian symbolism has come to mean many things to many people. This book therefore takes the form of an introduction or exploratory journey through Christian symbolism in its broadest sense. The opening chapters begin on the perimeters where symbolism has its origins in the world as we know it and Christian symbols share a common ground with the symbolic meaning found in other traditions. From there our journey takes us through the broader aspects of specifically Christian symbolism towards its central focus in the life of Christ. The breadth of the subject has resulted in certain omissions of which I trust the reader will be tolerant. Hopefully some compensation for this will be found in the Glossary with its shortened entries which may in themselves provide a source for further exploration by the reader on his or her own behalf.

Some reference needs to be made in this introduction of the great emphasis the Christian Church places on 'faith'. As Jesus so often said, 'Your faith has made you whole.' Faith, in its purest form, does not need symbols; and yet the symbols are there all of the time, to re-direct one's faith if and when it falters. They are so unobtrusive and yet so evocative that faith requires no explanation of them and yet they still

work invisibly and of their own accord, beyond the mind of man. When man's faith falters, as it sometimes does, he understandably seeks meaning for his existence in the material world which is his natural habitat, and it is here that symbols may be of use in redirecting man consciously or unconsciously back towards the higher planes of his existence. In that respect this book may be of little relevance to those Christians who are gifted with an unquestioning faith, but for those who are searching for a deeper meaning, whether inside or outside the Christian religion, I hope it will be of some service, and while perhaps not providing these readers with any direct answers it may at least present a point of focus for their own questions.

The word 'man' as it is used in the context of this book should be understood as including both man and woman, emphasising their common unity as both human and spiritual beings rather than their differences. As St. Paul says in his Letter to the Galatians: 'There is neither male nor female; for you are all one in Christ Jesus.' It has also been used because it automatically carries with it by implication a broader reference to man in general, as well as mankind and the physical world as it is known to man. A further reason for its persistent use is that we human beings have a natural habit of making things much more complicated than they are in reality, tending to see the multiplicity of things in God's Creation rather than its essential unity or the continuing presence of the Creator at work within it. It is one of the functions of Christian symbolism to shorten the distance between these two visions.

The quotations and references taken from the Holy Bible are from the Revised Standard Version and the superior numbers in the text refer to the notes accompanying each chapter. In Chapter 3 the asterisks indicate an expanded reference in the Glossary but elsewhere in the book the reader is left free to cross-reference in this way at their own discretion.

1 · SYMBOLISM AND CHRISTIANITY

The whole meaning, importance and value of life are determined by the mystery behind it, by an infinity which cannot be rationalised but can only be expressed in myths and symbols.

Nicolas Berdyaeff

A book about symbols and symbolism is almost inevitably something of a contradiction in terms because, at the same time as expressing the 'infinity' referred to by Berdyaeff, symbols lead us towards an infinite unity – and yet, as soon as we begin to analyse or define symbols as individual 'things' we start breaking that unity up into finite parts. Paradoxically, in exploring the possible meaning of a symbol we risk turning it into what is called a 'sign'.

There is no mystery about the meaning of a sign. At its simplest level, for example a roadsign, it is a practical, 'external' indicator that stands for, or informs us about, a known thing. On the other hand, a symbol is more the expression of something mysterious whose presence or existence, while still beyond the grasp of our rational mind, may be sensed in a way that is simultaneously 'internal' but distant. Through it our inner, unconscious or spiritual experience is united with our outer, sensory experience. As Father Sylvan in

1

Lost Christianity expresses it, 'The symbol is meant to guide the arising of the unifying force within ourselves, the force which can bring our aspects together, the force called "the Heart", the holy desire.'[1] To look at it more broadly, a symbol is an aid to help us resolve the apparent diversity or multiplicity of phenomenal things with the unity from which they emanate.

Modern man, confronted with the multiplicity of the phenomenal world, and simultaneously driven by his desire to understand it in rational or logical terms, has developed an insatiable appetite for definitions. At the same time, according to a summation of Jung's diagnosis, 'he is suffering from a starvation of symbols'.[2] A definition provides us with what is largely impersonal or second-hand information, whereas a symbol furnishes us with personal, direct experience. The one is associated with the workings of the rational or logical mind; the other arises more from an intuitive or inner perception. In the concluding chapter of *Christianity and Symbolism* (first published in 1955), F. W. Dillistone put forward that 'man's supreme need at the present time is to become related to powerful and meaningful symbols. They must be such as to integrate him into the "wholeness" of the natural environment to which he belongs: such as to bind him to his fellow-men by ties which are deeply "personal". They must on the one hand be flexible enough to allow for an expanding knowledge of the universe; they must, on the other hand, be of such a pattern as to make room for a continually extending dialectic between man and man.'[3] It could be added to this that modern civilized man has possibly largely forgotten the true nature and function of symbols, turning his knowledge and use of them into a 'science' rather than an 'art'.

The great age of Christian symbolism in the West was during the Middle Ages, reaching its peak somewhere between the eleventh and mid-fifteenth centuries. At that time the Christian religion was a comparatively unified and unifying force directing man's vision to contemplate the mysteries of God, the Incarnation, and the humanity and divinity of Christ. The Creation was seen as an expression of the unseen Divinity, and man sought to comprehend the invisible world of divine reality through the visible reality of his own world.

It was as though he had taken the words of Jesus to heart: 'For there is nothing hid, except to be made manifest; nor is anything secret, except to come to light.[4] For medieval man this world was a symbol and it was for man, himself part of the symbol, to explore and express the mysteries that lay behind it. The great medieval churches and cathedrals were one of the expressions of his search: simultaneously an embodiment of the 'church' or 'body' of Christ, an image of the Holy Bible and the Heavenly City, and a representation of the cosmos, they created a compelling and tangible symbol of the divine mysteries.

It could be said, however, that what was a symbol for medieval man has become little more than a sign for modern man, and where there was once symbolic meaning there is now little more than literal interpretation. This is hardly surprising when we consider the fundamental and extensive nature of the changes that have taken place in the world since those times. Modern man is very much more 'of the world' than his ancestors and his interpretation of it is consequently more literal than symbolic. What could be described as an over-concern with the material or external aspects of life has led to man losing touch with his higher or inner forces.[5] As a result of this the material reality of the world has become a veil, rather than a mirror, for the reality it symbolises.

Regardless of the way things might appear to be the archetypal symbols have remained with us and, although we may no longer regard it as one, the world has never ceased to be a symbol. In fact, coinciding with twentieth century materialism, there has been a deep re-appraisal of man's relationship with himself, the world, and the higher forces at work in both. This has manifested itself in a number of ways. For example, the current concern with the ecology of the planet corresponds with man's re-awakening awareness of the 'wholeness' or 'interconnectedness' of all life. At the same time a sense of yearning has aroused in man the desire to delve behind the outer appearance of life in order to come closer to the source of life – a type of yearning which is best described as a 'spiritual' quest, a search for inner as well as outer fulfilment.

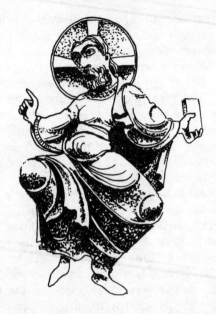

Figure 1. Christ. French, 12th century

A spiritual quest is a search for God, brought about by man's sense of separation from his Creator. It is a search for the Kingdom of Heaven with its promised reconciliation between man and God; but that kingdom is not some distant garden at the edge of the universe, nor is God a bearded old man floating vaguely around on a cloud somewhere. These were symbolic images derived from the known visible world in order to represent what is unknown and invisible. To interpret them literally, as fact, is inconceivable for the modern mind, and so it should be. They are now outdated symbolic images which, interpreted literally, tend to reinforce man's separation from God rather than bring him closer to the promised reconciliation. Outdated though they may be, however, they still symbolise the mystery of God's active participation in His Creation. It is the reality of this mystery which lies at the heart of Christian symbolism, for both the reality of this world and the reality of the divine mystery are brought together and united in Christ, in the actuality of God's presence in this world.

Christian symbolism, like any true symbolism, is inclusive rather than exclusive. Whether we encounter it in the Holy Scriptures, in the rituals of the Church, in a medieval altarpiece or a stained glass window, it is an expression of the infinite mystery that lies behind life as we know and experience it; it is not a definition of it. It is only when we try to define it in rational terms – in other words, when we try to render the infinite finite – that it becomes exclusive. To look at it from another viewpoint, a symbol is the meeting point or 'interface' between the visible and the invisible, between the finite and infinity; as such, it expresses the unity of life, not its duality.

TOWARDS CHRISTIAN SYMBOLISM

There have been two historical periods when the symbolic aspect of Christianity played an important and integral part in the Christian life. One we have already mentioned, the European Middle Ages; the other was the Byzantine Empire, centred on the city which has been variously known as Constantinople, Byzantium, and now modern day Istanbul. Although these two cultures were in many ways different they shared a common ground in that their perception of the world, and consequently their perception of life as well, was through Christian eyes. That is to say, the pattern and hierarchy of life on earth were a reflection or image, albeit imperfect, of the heavenly kingdom. Its imperfections were the work of man – its glory came from God, and life on earth was regarded as the journey from imperfection towards perfection, 'For our knowledge is imperfect . . . but when the perfect comes, the imperfect will pass away'.[6]

But, as Alan Watts reminds us, there are two ways of getting to 'the house next door'. 'One is to travel all the way round the globe; the other is to walk a few feet. There are two ways of finding the heavens. One is to journey upwards and upwards in quest of an ever-receding firmament; the other is to realise that here on earth you are already in the heavens and that our planet is in fact one of the company of celestial bodies'.[7] These two approaches correspond, loosely speaking, to the *via positiva* and the *via negativa*: the active

5

and contemplative lives which Martha and Mary are often seen to represent.[8]

In symbolic terms these two approaches to the 'journey' find their expression in the pilgrimage and the maze. The one undertaking a journey through time and space; the other moving inwards, towards a still, motionless centre. The Western mind, with its penchant for action rather than contemplation, has generally seen it as the former, tending to regard the latter as too 'mystical'; at least, that is, in the more materialistic environment of modern times. It has also, in some ways, adopted a similar attitude towards Christianity, its own religious tradition. The more Western society has moved towards materialism, the more it has eroded the mystical symbolism of the Christian Church. In this way Christianity has increasingly been defined by its outer or literal form rather than being turned to for its profound depth and universality: religious experience has become a small part of life rather than life becoming part of religious experience.

THE JOURNEY OF THE SOUL

In the language of the Christian mystics the journey through life has been expressed in terms of the 'journey of the soul'. In other words, there is both an outer 'physical' life and an inner 'spiritual' one. The passage of the former is self-evident; the latter is not, and that is why it is generally expressed through a symbolic language. In brief, the journey of the soul is a journey of yearning towards God; a journey in which the soul is nourished through the gift of the Spirit. It is also referred to as a process of transformation; a process by which the action of the Spirit transforms man into a 'spiritualised' being.

The journey or life of the soul is accompanied by references to birth, life and death which cannot be understood in their literal context, as Nicodemus demonstrates in his meeting with Jesus. When Jesus tells him, 'I say to you, unless one is born anew, he cannot see the kingdom of God,' Nicodemus responds with the question 'How can a man be born when he is old? Can he enter a second time into his mother's womb and be born?' Jesus answers, 'Truly, truly, I say to you, unless one is born of water

6

and the Spirit, he cannot enter the kingdom of God. That which is born of the flesh is flesh, and that which is born of the Spirit is spirit.'[9] This second birth comes with baptism for, in being baptised, the Christian receives the gift of the Spirit. It is a significant step in the journey of the soul, but its journey is not an easy one. As we are reminded, 'The spirit is indeed willing, but the flesh is weak.'[10]

SYMBOLIC LANGUAGE

In the language used for the journey of the Christian soul we find the forces that influence its course frequently expressed in terms which are understood all too literally by our modern minds; the language used to speak of an invisible reality or 'idea' being turned into a material 'fact'. Like Nicodemus, who understood Jesus' use of the word 'birth' in its physical sense, we are faced with words like 'flesh' and 'sin' which, while having one meaning in their literal sense, also have other implications for us to understand: as Jesus again explains to Nicodemus, 'If I have told you earthly things and you do not believe, how can you believe if I tell you heavenly things?' Perhaps this can be interpreted as meaning, 'If I have explained something to you in your own language and you have not understood its meaning, how can you understand if I tell you in my own language?'[11]

FROM MULTIPLICITY TO UNITY

The language of symbols also denotes the unity of life that lies behind the multiplicity of its exterior – a unity which finds its perfect expression in the image of Christ: 'He is the image of the invisible God, the first-born of all creation; for in him all things were created, in heaven and on earth, visible and invisible . . . all things were created through him and for him.'[12]

The universality of this image embraces all things within it and is helpful in coming to understand the universal nature of Christian symbolism, especially in its perception of the world as a symbol and the cosmological symbolism found in earlier Christianity. Whatever images it may present us with,

however, Christian symbolism should above all be regarded as a celebration of the mystery of God's active presence in the world, and of the wonder and hope this can inspire in man.

> What can be known about God is plain . . . because God has shown it . . . Ever since the creation of the world his invisible nature, namely, his eternal power and deity, has been clearly perceived in the things that have been made.[13]

> To see a World in a Grain of Sand,
> And a Heaven in a Wild Flower,
> Hold Infinity in the palm of your hand,
> And Eternity in an hour.

<div style="text-align: right">William Blake</div>

2 · THE ELEMENTS OF SYMBOLISM

WHAT IS A SYMBOL?

We can invent what is called a sign but we cannot invent a symbol. A sign generally indicates an otherwise known or finite thing. Its function is to communicate information; and so an effective sign should be instantly recognisable, with the minimum possible ambiguity of meaning. In other words, there is a direct and self-evident correlation between the sign and what it signifies. In the modern sense it is a convenient way of conveying practical information. It is one tangible reality expressing another, equally tangible, reality.

A true symbol differs from a sign in that what it expresses is ultimately intangible. The symbol itself might well be a tangible, instantly recognisable object or concept but there is frequently no obvious or visible relationship between the symbol and what it expresses. If we endeavour to create a tangible reality of the mystery it symbolises, we will forever be turning symbols into signs. For a symbol to remain a symbol, we must accept that what it expresses will remain a mystery: a mystery which can only begin to be experienced as we overcome the apparent distance which separates us from the symbol. In other words, when we transcend the outer, tangible

appearance of the symbol we encounter the transcendent reality which expresses itself through it. This is what gives human beings their unique position in relation to other known life forms – the potential to perceive a transcendent reality revealing itself through the material reality of this world.

SEEING THE SYMBOL

Symbolic meaning may reveal itself through different kinds or types of symbols. The symbol may present itself in the form of words, a visual image, or a variety of other, more subtle, ways. Because we are 'thinking' beings, our mental or thought processes are involved, to a lesser or greater extent, in the way in which we perceive symbolic meaning. Our response to the particular form of each symbol involves different processes, some of which are at a more conscious level than others. For example, our response to the symbolic 'word' is different to our reaction to the symbolic 'image'.

The word, whether written or spoken, is sequential; that is, it consists of a sequence of words, delivered in a linear manner, one after the other. The full import of the word is not revealed until the verbal or written account being delivered is complete. This process involves a particular function of the mind which acts rather like a filter, registering the words as they pass through it. Once the account has come to an end the different parts fall into place and we are then free to review, or refer back to, the whole or specific details, if we wish. Next, the mind may delve deeper into the word, at a conscious or unconscious level, exploring it for further meaning or increased understanding.

The presentation of the visual image, on the other hand, is not sequential or linear. It is simultaneous, the constituent parts of the image acting in parallel unison as a whole; that is, we see the whole and its constituent parts at one and the same time. In much Christian art, up to and including the early Renaissance, it is not uncommon to find two or more related episodes from a biblical narrative, or a 'type' and its 'antitiype' (See Chapter 4, 'Typology'), depicted in the same image. In this way an image could go beyond the conventions of 'time' and, to some extent, 'space', by compressing them both into one moment and place.

The assimilation process is initially visual, through one of the senses, and is therefore sensory rather than intellectual. Our mind is not, as yet, acting as a filter, and so our primary response to the image is an emotional one. As we look at the whole image we may be drawn to one or more of the details on which we then focus our attention, but they still remain integrated within the whole. Next our conscious or unconscious mind may then come into play as we begin to respond to the image on the mental plane, linking the image and details it receives to its memory of other images, possibly even to other emotions similar to the one we have just experienced.

The symbolic meaning contained in the word or image may be presented in any one of a number of forms: legend, myth, allegory, metaphor, or analogy. All of these draw on a reality originating, to a variable extent, in this world to express another reality. In the context of Christian teaching one of the more obvious examples of this is the use of parables by Jesus, especially those describing the kingdom of heaven. (See Chapter 5, 'The Parables')

SEEING BEYOND THE SYMBOL

It must be understood that whereas it is possible to see things in purely literal terms, without any symbolic connotations, it is not possible to see things in symbolic terms without also seeing them literally. The literal or material reality is a necessary pre-condition, without which there can be no symbolic expression. The material form is also the potential symbol. It is like the window in a room, providing us with a view of the world outside. The glass of the window pane, although not visible to us as we look through it, is the physical meeting-point between the room and the view beyond it. However, if we focus our eyes on the glass, the view beyond it becomes blurred. The closer we are to the window, the more blurred the view beyond it will become, and the greater the adjustment we will need to make in refocussing our eyes in order to see the view clearly again. Try it and see!

To take the above analogy a little further. The view is there all the time, whether we can see it or not. The more we focus on

the glass, the less we see the view. The more literal or material our outlook, the less likely we are to see the transcendent reality expressed through it. If we really do not want to see the view at all, we can always close the curtains. On the other hand, we could open the window and breathe in the air from the world outside!

A symbol may provide many meanings or infinite levels of meaning. Its ability to do so depends entirely on us and our perception or interpretation of it. In *The Language of Mystery*, Edward Robinson refers to a traditional scheme for four levels of interpretation of any biblical text. The same scheme is also useful in the interpretation of symbols.

> At the *Literal* level it could be taken as a record of simple fact or instruction. From this one could go on to interpret it at the *Allegorical* level; here each element in the text could be understood as standing for something else. The third level was the *Moral*, at which the text could yield a meaning of particular relevance to the reader's own situation; this could be described as the personal level. The fourth and highest was the *Anagogical* or mystical level. To interpret scripture at this level meant to open oneself up to all the infinite meanings that its words might have for you, meanings that might well transcend the comprehension of any single individual.[1]

It is important to stress that although the reference to different 'levels' of meaning might imply that these levels are in some way separated from each other, they are not. They are all simultaneously present, one 'within' the other. Our first contact with the symbolic object is a purely external one; that is, it is on the literal level. This initial experience is through our senses – through sight, sound, etc. In whichever way we experience it, the object or event is perceived as being limited by time and space rather than as a symbol or potential symbol. At this stage it is experienced as something outside of us, and may have no apparent symbolic or inner significance.

At the second level we go beyond our first, sensory impressions and our experience of the object begins to expand. We come to a different, allegorical or mental perception of the object. This is frequently acquired from an external didactic source, such as a book, or a verbal or visual stimulus of some

kind. At this stage our mind comes into action. In opening up to other, non-sensory perceptions of the symbol, we begin to free it from the limitations of time and space. In a sense we have moved towards the object or event and, through this action, it has come closer to us. It is no longer seen from a distance, in isolation, as being separated from the rest of our experience. At this stage, however, we need to proceed with caution because it is here that the mind can make the symbol its own. Instead of allowing the opening-up process to continue it seeks to define further or rationalise what it has perceived. Having been instrumental in freeing the symbol from the restrictions of time and space, the mind now tries to re-impose them on its own terms. In other words, it sees it as just another piece of second-hand information to put away somewhere in its vast filing system. For the symbol to work as a symbol we need to keep our mind open so that it can be instrumental in helping us on to the next level.

In the second, allegorical stage the symbol has, in a sense, been 'activated'. Now, provided that our mind remains open, the symbol can begin to 'act' through it. The mind, in response to this, and in no longer seeing itself as somehow separate to the symbol, links itself with what the symbol symbolises. It begins to associate it with its memory, sometimes very distant, of other experiences and, in doing this, it brings the symbol into the realms of our own personal experience. At this third, moral or personal level, the symbol is no longer second-hand information; in acquiring relevance for us at a personal level, it becomes first-hand experience. This is the stage at which we may begin to acquire a heightened awareness of ourselves and our seemingly extraordinary and intimate relationship with the external world and everything in it. It may appear as though everywhere we turn there is a mirror reflecting back to us what we need to see, but have previously ignored.

At this point we may also become alive to the tremendous lifeforce or energy flowing through the whole of creation. We may think that this energy or power emanates from us rather than passing through us. We may even begin to think that we have found the secret to life on earth and that we have 'seen' God. Beautiful as these experiences might be, it is only our

mind taking over; it is once again trying to rationalise things. It may lead us to believe that 'we' have achieved something when, in reality, a bit of us (our sense of separation) has begun to melt. In fact, our inner senses have been awakened, providing us with genuine insight into worlds which cannot normally be perceived through our physical 'outer' or 'lower' senses. Unless we again proceed with caution we may try to replicate these experiences with our mind, projecting them outwards as rationalised concepts, and it is then these that we see being reflected back to us. The temptation at this third level is to turn our heightened awareness into 'personalised', egocentric experience, rather than learning from it what we need to learn in order to go beyond that.

So far there has been a gradual reduction in the distance between the observer and what lies beyond the symbol. At the second and third levels, whatever it was that separated the observer from the symbol has been dissolved. At the fourth, anagogical level, it is the importance that may previously have been attached to the physical nature or material form of the symbolic object or event which melts, making way for a new light of understanding. In other words, the symbol itself dissolves as what it symbolises flows uninterrupted through the observer's mind. Our personal vision now gives way to another vision which seems not to be ours. This new vision expands beyond the comprehension of the rational mind; instead of 'thinking' it is as though 'thought' passes through us. This is the level at which true contemplation or meditation takes place. From here the contemplative's vision may lead to the mystical 'fire of love' in which he is consumed by love and where, as the final barriers of separation are burned down, lover and Beloved become as one.

This last mystical part of the process is put into words by Richard Rolle, the fourteenth century mystic. '. . . in him who attains the height of contemplation with joy and ardent love, the desires of the flesh [those emanating from self-interest or our own lower nature] now lie virtually dead. It means death to evil longings [longings for other than the Lord] for the man who surrenders himself to contemplation, whose inner self is

being changed to a glory and pattern that is different. Now it is "no longer he who lives, but Christ who lives in him" [Galatians 2:20], and as a result he is overwhelmed by love and longing for him. His is the soul that says, "tell my Beloved I am pining for love" [Song 5:8]; I am wanting to die; I long to pass away; I am burning to pass over. See I am dying through love!'[2]

Not everyone seeks the passionate mystic experience described by Richard Rolle. It might seem out of place here with its ecstatic references to death; but the death he is referring to is symbolic, not physical. It is a death which brings new life through the reconciliation of man with his Creator.

THE SYMBOLIC UNION OF OPPOSITES

A symbol is a meeting-point. It brings about a potential reconciliation between two apparent opposites: for example, between the material and the transcendent, the conscious and the unconscious. These things are not really in opposition to each other, nor separate from each other; but in order to understand the wholeness of things we break it down into its constituent parts – and then we may break them down even further, and so on, *ad infinitum*. It is not unlike dismantling a complex piece of machinery to see how it works. The problem is can we re-assemble the parts so that the machinery functions effectively once more?

This quite natural tendency to analyse and take things to pieces is due, in part, to the paradox of what can be referred to as the duality or multiplicity of manifestation. In other words, the variety of life is seen as a collection of more or less independent parts. If we focus our attention on the parts, we may lose sight of the whole. It is possible, however, to see this from the opposite viewpoint; that is, to see unity in diversity – to keep in the forefront of our mind the wholeness which lies behind the parts. This is where we encounter the meeting-point provided by symbols. They are part of the multiplicity of manifested 'things' and yet are also vehicles for expressing the infinite unity which they constitute.

15

Instead of seeing both the parts and the whole, we see them simultaneously, as one.

MICROCOSM AND MACROCOSM

Man is the microcosm, the 'little world'; the universe is the macrocosm, the 'great world'. The underlying principle behind the concept of microcosm/macrocosm lies in the links, actual and symbolic, that exist between the two, whether these are perceived in terms of, for example, common chemical elements, astrology, or the sharing in one divine source. In essence, man, 'the measure of all things', is 'universal man', the mirror of the cosmos. This does not mean that he is necessarily superior to the rest of creation; it is more an indication of his functional position within the created order of things.

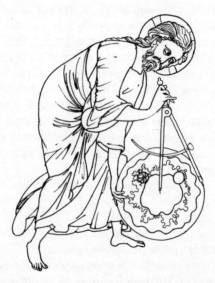

Figure 2. The Divine Geometer. French, 13th century

Whereas the nature of the universe reveals the cosmological laws, man is alone in Nature in having the ability to register these laws consciously. He is also alone in having the potential to apply consciously the universal to the particular, and the

16

particular to the universal. Some of the most significant and fundamental discoveries made by man stem from such a correspondence. Pythagorean geometry, for example, in which 'all things that are known have number', expresses the inherent harmony within nature and the universe. In formalising this underlying harmony, this 'music of the spheres', man felt he could attune himself to the harmonic proportions through which a mysterious unity appeared to impose its order on the structure of the universe. The knowledge thus gained was applied to understanding and ordering the details of man's own world. This world, the world as it appears to man, was seen as the image of another world. It was the invisible making itself known through the visible, and geometry was seen as the key to the secrets of both.

In Christian iconography God is sometimes portrayed as the Divine Geometer, the Great Architect of the Universe. At the Creation, compass in hand, He divides the light from darkness, and heaven and earth from the waters.[3] This image also symbolises the apparent duality of God's Creation. The two points of the compasses, or 'dividers', which represent the event of the Creation, are united at the point where they separate, in God's Hand. This single point symbolises the infinite unity of God. It contains all space in *potentia* and is thus present at every point of space while transcending it. This symbolic point precedes the dimensional world and is therefore, in itself, beyond dimension, immeasurable, and unknowable.

THE MEETING POINT OF TIME AND SPACE

To the three spatial dimensions of height, width, and depth, we need to add the fourth dimension of time. Time, like space, has its own natural order. For example, there are the regular, measurable cycles of time, witnessed as days, lunar months, years, etc. Man's actual, conscious experience of time is usually in linear terms, perceived as a straight line running from birth to death. It is this linear experience of time which, to some extent, has set man at odds with Nature. We witness time as a series of points, marking the measure of its duration or finality, rather

than feeling ourselves as integrant in its natural cycle. The perception of time as finite leads us to see death as the end of life. This is the opposite of the cyclical view we witness in nature and in the seasons where death precedes life in an eternal round of demise and renewal.

Symbolic time, although represented by numbers, is, like symbolic space, immeasurable. In emanating from the same single point, the infinite unity at the centre of the creative dividers, it contains all time in *potentia* before unfolding itself into 'time' as we know it. It defies the descriptive measure of linear time because it is simultaneously the beginning and the end, the demise and renewal of time. The point at which the perpetual cycle of death and rebirth occuring at one and every moment of time comes into linear time is often referred to as 'the eternal now'.

In theory we may be able to talk about space and time as separate measurable phenomena but in physical reality, as the four basic dimensions of man's experience, they are inseparable. They have become the space–time of modern physics. The same also applies to symbolic space and time: united in a symbolic 'space–time' they signify the permanent flux of the Creation which, being beyond all dimension, is both immeasurable and beyond the rational comprehension of the human mind. A distant glimpse of this is, however, not beyond human experience. This experience usually coincides with an increased, sometimes intense, sensation of being at one with life or nature, with another person or a group of people (sometimes it may even correspond to an inexplicable feeling of total isolation), in which time seems to stand still or accelerate. However we experience it, our normal awareness of space and time expands or contracts, or even appears to do both simultaneously. It is as though there were a meeting, a union, between 'worlds' – between the normal dimensional world and a world beyond dimensions.

This union is such that it cannot be broken down into constituent parts. It therefore has the potential to free us from the illusory bonds of space and time; the bonds from which the need arises to define every 'thing', to fix each event as happening in one particular place and at one particular

point in time. The product of this illusion is a static rather than dynamic arena of events. When things are static there is no creative flow, no active meeting-point between material and transcendent reality, and consequently no symbolism.

If we acknowledge that there are both a material and a transcendent reality, they must meet somewhere. It has been suggested that the point at which they meet is life itself; that is, in 'life as a symbol', with the transcendent reality expressing itself through the material reality. It is life lived at 'that point where the visible serves only to draw attention to the invisible'.[4] Such a viewpoint should not be interpreted as in some way opposing a materialistic or literal, non-symbolic, view of life. That is to miss its essential point, which is that all life is a potential key to the infinite mystery behind it.

SYMBOLIC MYTH AND HISTORY

While we accept history as being true, it is not uncommon to question the historical veracity of myths and legends. As S. H. Hooke points out, 'the right question to ask about a myth is not, "Is it true?" but "What is it intended to do?"'[5] The short answer to that question is myth and legend take us out of historical time, providing a further, dynamic dimension to history. In very generalised terms, a legend has an historical origin which has been expanded beyond the realm of historical fact, taking it outside the confines of place and time. A myth, on the other hand, has its origins beyond place and time but is related in historical terms, although not necessarily with the intention of being interpreted as historical fact.

Traditional myths express the active participation of an unseen force or forces at work in the world. The greater the effects of this participation are seen to be, the more involved in the unfolding of history they become. The belief, held by the writers of the Old and New Testaments, that God is actively present in human history meant that their use of symbolic myth was almost inevitable in order to express the mystery of His presence; to express those 'moments in history when events

take place whose causes and nature lie beyond the range of historical causation ... to express in symbolical terms, by means of images, what cannot be otherwise put into human speech'.[6]

With the advent of Christianity God's active presence in the world, expressed in the Old Testament through His participation in the history of a nation, the Israelites, His Chosen People, was now expressed on a more personal level through the historical life of Jesus. The writers of the New Testament, coming as they did from a Judaic background, and therefore familiar with the mythological elements of the Old Testament such as the Creation, described what they saw as a new creation and a new covenant using 'the same mythological patterns to clothe the historical events in which the divine activity was expressed'.[7] For example, the correspondence between the Creation of Genesis and the 'new creation' sees Jesus named as the Second Adam, and his birth, the Incarnation, like the birth of the original Adam, is through the Breath or Spirit of God. (See Chapter 4, The Second Adam.)

For medieval theological historians the eternally active presence of God was the very root and cause of history. In chronicling historical events they saw their role as fulfilling a specific function – the historical narrative was 'required to demonstrate that ... events-in-the-world have three values: the literal, the symbolic, and the anagogic, and that the significance of any event will be incomplete until the multiple values have been demonstrated'.[8] Their view of history was the same as that of the writers of the biblical Scriptures – it was history as theophany, the manifestation of God's presence in the world, through which man might come to understand the mystery of his relationship to God. As John Scotus had said in the ninth century, 'The Word descended into man in order that, through it, man could raise himself to God.'[9] Since that time the evolution in man's thought, especially in its swing towards more humanist philosophies, has led to a twentieth century Christian view phrasing it slightly differently: 'Humanity's groping quest for God is animated by God's quest for man.'[10]

ESCHATOLOGY: 'THE END OF THE WORLD'

When interpreted in purely historical terms 'the end of the world' has a disconcerting ring of complete finality about it because it implies the death and obliteration of everything. It is the full stop at the end of linear time . . . after which there is nothing. It is the end of history.

From a symbolic viewpoint 'the end of the world' is, in simple terms, the end of the world as we know it, which is not at all the same thing. What we as individuals, or as mankind as a whole, know about the world is in a constant state of change or re-adjustment. Our perception of it is subtly changing all the time. The world as we know it today is different to the way it was known one thousand years or fifty years ago; the way we know it today is even different to the way we knew it yesterday. In linear terms everything we know is related, in one way or another, to the image of the world as we perceive it to be. In that respect, at least, there is no change – it is a this-worldly perception, governed by man's conventional notions of time and space, and of himself. Does this perception have to change? Does it need to change? No, it doesn't. That is, from its own point of view it doesn't. Man has lived with it since the time of Adam and survived, so far. It could, in fact, be referred to as an 'Adamic' perception in which a world, rendered finite by the dimensions of time and space, appears to have been made for man to govern or rule over; one which, by defining where it begins and ends, he can come to understand. The world-as-we-know-it is coterminous with this perception.

Theories, doctrines, prophecies, or teachings which concern themselves with the end of the world are known collectively as 'eschatology' – 'the science of ends' (Greek *eskhatos* = 'last'). Christianity has been described as 'an eschatological, not a historical, religion – for its whole hope is directed towards *Dies illa*, 'that Day', upon which time and history will come to an end'.[11] The expression used in the Bible to convey this time is 'the Day of the Lord' or 'the coming of the Kingdom of God'. These refer to 'the Day' when God will manifest Himself in the world and reign over it, banishing its misery

and suffering. It is the hoped-for day of the Kingship or Lordship of God. To look at it another way, it may be seen as the time when man, renouncing his own Adamic vision of himself as 'lord and ruler' of the world, will acknowledge the Lordship of God and become his Creator's willing servant in the fulfilment of His purpose. This new world, or new vision of this world, cannot come into being without the old world passing away.

The Old and New Testaments contain many eschatological passages, culminating in the apocalyptic vision of 'The Revelation to St. John'. These passages generally portray the end as a time of strife, destruction, and death, bearing with it the promise of a new beginning or a new world with a hoped-for life of peace and harmony. 'Then I saw a new heaven and a new earth; for the first heaven and the first earth had passed away, and the sea was no more . . . And I heard a loud voice from the throne saying, "Behold the dwelling of God is with men. He will dwell with them . . . He will wipe away every tear from their eyes, and death shall be no more, neither shall there be mourning nor crying nor pain any more, for the former things have passed away."'[12]

Man's Adamic perception is that of 'first' or 'former' man, arising from the apparency of his separation from God (symbolised by the Fall and the Expulsion from Eden, when he was cast out into the world), and from the all-too-apparent finality of death. Because this view sees the world through the finite eyes of history it can only begin to give way to a new perception when it encounters an historical event which either re-establishes the relationship between God and man or demonstrates the non-finality of death, or both. Such an event, while being perceived in historical terms, would also transcend history and be simultaneously relevant for all 'time': past, present, and future. For the Christian this event is the Death and Resurrection of Jesus Christ.

THE COMMONALITY OF SYMBOLS

It was suggested earlier that life itself is a potential key to the infinite mystery behind it. In other words, life, regarded

symbolically, is the material reality through which the transcendent reality expresses itself. It is also therefore the vehicle by which, to some degree at least, we are able to experience consciously or unconsciously the presence or workings of that same transcendent reality. For this reason it should not be surprising to find that some of the more potent symbolic forms are often those most closely connected to our daily experience of life, and that many of these are common to more than one religion or are shared by otherwise apparently independent cultural or artistic traditions.

WATER AS A SYMBOL OF LIFE

Water, for example, appears in a multitude of forms – sea, river, pool, fountain, rain, dew, etc. It is essential for sustaining life – flowing out of a tap, being drawn from a well, irrigating the land, etc. Its movement is contiguous with life itself as we 'sink or swim', or go 'with the flow' or 'against the tide'. Symbolically it reflects these life-giving or life-sustaining properties in becoming the primordial waters or 'waters of the deep', the *fons et origo* from which life emerges. It becomes the 'sea of life' over which we sail towards what awaits us on the other shore, possibly tossed by storms or becoming shipwrecked on the way. Water, giving life to man, also gives life to gods and goddesses, and is the birthplace of, for example, the Hindu deity Agni and the Graeco–Roman Aphrodite or Venus. There are similarities in the infancy narratives of the Assyrian Sargon, King of Agade, and Moses; both of whom were born in hiding and then placed on a river in a basket of reeds or rushes. Their ensuing 'discovery', when they are lifted out of the waters, may be regarded as a second, symbolic birth, which prefigures their subsequent position of eminence and authority amongst their fellow men. The name 'Moses' (Hebrew: *Mosheh*) commemorates this event, '. . . and she named him Moses, for she said, "Because I drew him out of the water."'[13] (A further significant dimension is added to Moses' origins when we consider the symbolism of 'Egypt'. (See Chapter 4, 'Further typology', and Glossary). Water is also the domain or dwelling place of gods such as the Egyptian, Nun; the Sumerian, Enki;

the Graeco–Roman, Poseidon or Neptune; the Hindu, Varuna; and the Scandinavian, Njord; not to mention the countless lesser gods, nymphs, magic fish, and sea monsters who help or hinder those traversing the symbolic sea of life.

This synonymity of water and life is an essential part of Christian symbolism but it is given additional meaning by an inner baptism through the Spirit. The Gospel of Mark opens with the baptism of Jesus by John the Baptist with water from the Jordan: 'And when he came up out of the water, immediately he saw the heavens opened and the Spirit descending upon him like a dove.'[14] The Christian life also begins with baptism, the sacrament of Holy Baptism marking the beginning of a new life, a new birth 'in Christ', through water and the Spirit. The association of water symbolism with Christ extends to his personal symbol of the fish, to his disciples who are 'fishers of men', and to his miraculous acts of calming stormy seas and walking over the water. He is also the 'living waters' and, as the Lamb, sits enthroned with God at the source of the 'river of the water of life' which flows through the centre of the Heavenly City.[15]

THE SYMBOLIC 'TREE OF LIFE'

While water may be seen as broadly corresponding to life in terms of 'living', the tree represents the whole of life. It is the 'Tree of Life', through and from which the sap or water of life flows. From its roots in the earth it grows towards the heavens, establishing itself as a link between the two. Its growth is dependent on the four elements: earth, water, air, and the fire of the sun; yet it is also self-perpetuating, growing out of the seed of its own fruit. As the Cosmic Tree it is simultaneously the central axis and the sphere of manifestation that revolves around it. In some traditions it symbolises what is called the 'Centre'; the Source from which all things emanate and by which they are sustained. This may be represented as the Tree of Life, from which the Four Rivers of Paradise flow out into the four corners of the world – an image repeated by the cross with its central point and the four arms stemming from it. Alternatively, it may be depicted as a three-dimensional

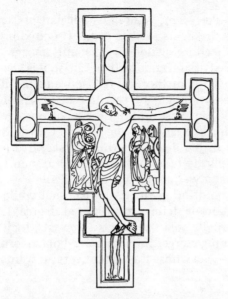

Figure 3. Crucifix. Italian, 13th century

cross; that is, a central point with six arms radiating out in all directions. (For the significance of these combinations of numbers, see the Appendix on numerical symbolism.) The tree, with its tripartite division of roots, trunk, and branches, also corresponds to the three principal divisions of man: body, mind (or soul), and spirit.

A simplification of these symbolic associations connected with the tree presents it as an image of both macrocosm and microcosm, at the same time providing a symbol that links the two. This symbolic meeting of worlds which gives the tree its importance is underlined by the wisdom it is able to impart. This is no ordinary wisdom, however, but one which brings with it supernatural and visionary powers. Receiving this wisdom entails self-sacrifice in one form or another. For example, in Norse mythology Odin receives the wisdom of the runes by hanging himself for nine days from *Yggdrasil*, the World Tree. The Buddha, too, received his Enlightenment during a period of ascetic meditation seated beneath the sacred fig-tree, the Bo tree, the Tree of Wisdom.

The tree, like water, is an essential part of Christian symbolism. It is the Cross or Tree of the Crucifixion which, free from any other implications, is instantly recognisable as the symbol of the Passion and Death of Christ. It is also the symbol of Christian faith in the Resurrection and the Redemption, brought about through the sacrifice of Christ on the Cross. Furthermore, the Cross unites the symbolism of water and the tree, for by his baptism into 'the body of Christ', the Christian participates in his death, sharing the sacrifice on the Cross through which he is born into a new life, nourished by the 'spring of water welling up to eternal life'.[16]

This last point brings us to the fact that while we may be able to explain or define, to a limited degree, the symbolic meaning of single objects, there is a stage at which one symbol and its meaning merges into other symbols to form an infinite and intricate web whose threads converge towards one central point.

3 · Aspects of Christian Symbolism

A brief explanation is necessary regarding the word 'art' as it is used, somewhat guardedly, in the context of this book. Whereas a twentieth century perspective probably places greater importance on 'the artist', as creator of the work, than on 'the work of art' itself, in pre-Renaissance Christian art the reverse was generally the case; as there was only one Creator, the artist was merely the anonymous instrument of His, the Creator's, work. The signing of works in those circumstances was more for the practical purposes of identification, rather than as a statement of the individual's own authorship. This attitude was more obvious in written works which were prefaced with a humble dedication to God.[1] As Ananda Coomaraswamy asks: 'Is it for the Christian to consider any work "his own," when even Christ has said that "I do nothing of myself"?'[2]

The underlying purpose of all Christian art is expressed in the lines Abbot Suger had inscribed on the gilded west doors of the

twelfth century abbey church of Saint Denis:

> Whoever thou art, if thou seekest to extol the glory of these doors,
> Marvel not at the gold and the expense but at the craftsmanship of the work.
> Bright is the noble work; but, being nobly bright, the work
> Should brighten the minds, so that they may travel, through the true lights,
> To the True Light where Christ is the true door.
> In what manner it be inherent in this world the golden door defines:
> The dull mind rises to truth through that which is material
> And, in seeing this light, is resurrected from its former sub-mersion.[3]

In the sense proposed by Suger, the purpose of Christian art is to direct one's thoughts and aspirations heavenwards; the material 'object' is simply the vehicle for this. In other words, Christian art is essentially a symbolic art. We can sense this clearly when our eyes look up at the spire of a great church or cathedral; and maybe we can feel it in our hearts when we contemplate the mysteries expressed through an ancient altarpiece or icon.

SECRET SIGNS OF THE EARLY CHRISTIANS

The use of visual images was formally forbidden by the early Church Fathers and by the inherited words of Mosaic Law: 'You shall not make for yourself a graven image, or any likeness of anything that is in heaven above, or that is in the earth be-neath, or that is in the waters under the earth.'[4] Imagery was not only a source of idolatry, its portrayal of 'earthly things' was also reminiscent of paganism. In addition to this the early Christians were a persecuted minority, and the overt use of images related to their beliefs would have attracted the un-welcome attentions of their enemies. The earliest symbols used by Christians were therefore more in the manner of secret signs. Clement of Alexandria sanctioned their use on signet-rings; or they were employed as decoration on glassware, lamps,*

*See glossary

28

Figure 4. Variations on the Chi Rho monogram

and other practical objects which had themselves taken on a new connotation. Although many of them might nowadays be regarded more as signs than symbols, even the simplest Christian sign was rich in symbolic significance because of its association with the mysteries of Christ and the Incarnation of the Word or *Logos*.

Amongst these earliest signs was the *Chi Rho* monogram, formed by superimposing X (*Chi*) and P (*Rho*), the first two letters of the Greek word 'Christos' (ΧΡΙΣΤΟΣ). This created a six-armed figure, rather like the spokes of a wheel,* which was sometimes increased to eight by the addition of a horizontal bar representing the horizontal arm of the Cross.* The initial letters of the Greek words '*Alpha*' and '*Omega*'* (Α Ω, or A-ω) were also used, as was the word 'Icthus' (ΙΧΩΥΣ), meaning 'fish'.* It was not long before the fish itself was portrayed, along with birds,* animals,* and other subjects whose symbolic significance was self-evident to Christians but obscure to the uninitiated. Simple representations of the dove,* the phoenix,* the peacock,* the lamb,* loaves of bread,* and the vine* soon abounded, laying the foundation for the figurative and symbolic nature of Christian art.

THE ART OF THE CATACOMBS

Ancient underground burial chambers known as catacombs exist in several Mediterranean countries, but it is the catacombs used by the Christians in Rome which are of particular

interest in following the development of Christian art. Whereas cremation was common amongst Romans, the Christian population, through their belief in the resurrection of the physical body, preferred inhumation, and when surface burial sites became overcrowded it was only natural to extend them below ground. In times of persecution the faithful met there secretly, until the Edict of Milan (313) gave them the freedom to worship openly and therefore construct buildings specifically for this purpose. From that time onwards the catacombs were used more as shrines, or places of pilgrimage; the underground churches to be found in them date from this later period.[5]

The wall paintings executed in the catacombs during the third and fourth centuries illustrate the transition from symbolic motifs or emblems to the representation of the human figure. It is here, too, in the land of the dead, that are to be found some of the earliest, tentative images of Jesus Christ, he who promises eternal life. Some of these early portrayals are allegorical, depicting Christ as Orpheus charming the animals with his music; an image that links him to David, the musician-king who prefigured him. Others show him as the Good Shepherd, standing amongst his flock with a sheep* slung across his shoulders.[6] In both these types of image he is a beardless young man, stylistically looking back to the youthful gods of classical Greece and Rome. By way of a contrast, one fourth century image shows him as he will be depicted for centuries to come – the bearded man with the halo* or nimbus indicating his divinity, although here there are the added *Alpha* and *Omega*, with Christ placed centrally between them. The Virgin and Child are also represented, as are scenes from the Old and New Testaments – Adam and Eve, Noah and the ark, Jonah and the whale, the Annunciation, the Baptism of Christ, and the Marriage at Cana; and so is the Raising of Lazarus, with its timeless message for man of his conquest of death through Christ.

THE ART OF BYZANTIUM

The symbolic character of Christian art is particularly apparent in what was the old eastern part of the Roman Empire, centred

on Constantinople, which rose to greatness when the Western Empire succumbed to the invading barbarians. The Emperor was ruler of a Christian Empire, his authority granted him by divine sanction, and the Byzantine Empire itself was 'the Kingdom of God on earth, the pale reflection of the Kingdom of God in Heaven ... The duty of art was to supplement the doctrine of the Incarnation, to show the divine in its light and colour in forms that human sensibility could comprehend'.[7]

This was art as theology. Its doctrine echoed the words of the fifth century mystic, Dionysius the Areopagite: 'The essences and orders which are above us are incorporeal ... Our human hierarchy, on the other hand, is filled with the multiplicity of visible symbols, through which we are led up hierarchically and according to our ability to the unity of God.'[8] Religious images thus hovered mid-way between earth and heaven, bonding together the material and spiritual worlds. The stylised figures that stared down at the worshipper from the interior walls of the church, the House of God, signified the divine presence that was also there. But representations of the visible human form of Christ, or that of the Virgin Mary (proclaimed 'Mother of God' by the Council of Ephesus in 413), and the reverence duly accorded them, could not escape accusations of idolatry, nor the eighth and ninth century waves of iconoclasm. Defence of the image was explicit: 'Christ is venerated not in the image but with the image,' or again, 'The icon is the door opening the God-created mind to the likeness of the original within'.[9] It is in this spirit that the Byzantine church building may be considered as 'a single vast icon';[10] the building itself, its lavish mosaic decoration and the liturgical ritual forming an integrated whole. Although later history may have witnessed the disintegration of the Byzantine 'Kingdom of God on earth', its traditional regard for the icon (Greek: *eikon* = image) or painted image has been maintained in the Eastern Orthodox Churches.

THE DEVELOPMENTS IN THE WEST

Whereas the eastern half of the old Roman Empire enjoyed a prolonged period of continuing unity, the civilisation of the

western half disintegrated under a succession of barbarian invasions. Gradually, however, the diverse pagan tribes and kingdoms were brought together, at least spiritually if not politically, by the spread of Christianity. The symbolism of the new religion also provided a unifying force for the various artistic, mythical, and legendary traditions which, while outwardly possibly appearing to retain some of their earlier pagan characteristics, were subtly woven together by the common thread of the Christian religion.

With the passing of the millenium, and its attendant fears of the end of the world, it was as though medieval man turned his gaze heavenwards in gratitude. The reciprocal expansion of the Church at that time manifested itself physically, in its buildings, as it went out into the world to meet him. In his 'Historiae', written at the beginning of the eleventh century, the monk Rodolphus Glaber uses the imagery of the 'white garments' of Christ's Transfiguration to convey the deeper significance he attached to the transformation he saw taking place: 'A spirit of generous piety motivated each Christian community . . . One might have said that the world itself stirred to shake off its old garment in order to cover itself everywhere with a white cloak of churches'.[11] Where earlier churches existed they were either enlarged or, more often, demolished to make way for newer and larger edifices. The rebuilding of monastery and abbey churches was accompanied by the building of many impressive urban churches and cathedrals; such was the fervour of the age that sometimes whole communities would participate in whatever way they could in the building of 'their' church. It was also the time of the Crusades, and long pilgrimages to Jerusalem, Compostella, Chartres or Canterbury.

Schools of learning, centred on the abbeys and cathedrals, expanded, becoming the focus of intellectual life. One of the most influential was at Chartres, where the aesthetics of St. Augustine combined with the philosophy of Plato to produce a synthesis of theology and cosmology that was to have a profound effect on the development of Christian symbolism during the twelfth and thirteenth centuries. The great churches and cathedrals which reflect the spirit and faith of that era became an embodiment of the 'symbolic interconnection

between cosmos, Celestial City, and sanctuary'.[12] Appropriately the cathedral at Chartres remains one of its outstanding monuments.

In contrast to the plain exteriors of the Eastern churches those of the West developed an elaborate use of external sculpture. The doorways in particular, and sometimes the doors themselves, became peopled with a host of figures and narrative scenes drawn from the Bible. In some cases the sculpture extended over whole facades, even occuring in elevated or out of the way positions that were barely visible, if at all, to the observer from the ground – on towers, spires, buttresses, or carved water spouts (gargoyles). The interiors were not neglected either, their sculpture, wall-paintings and stained glass all serving to give tangible life to the biblical mysteries. The three-dimensional stone or wood sculpture was frequently provided with added realism by the application of increasingly naturalistic colour (polychrome), traces of which have also been found on the sculpture of various facades from the period. The subject-matter was generally represented according to a conventional but gradually evolving iconographical system, formulated by those who directed its re-creation in stone, glass or paint, and recognised by the observer. Non-biblical subjects were also included, taken from apocryphal works (e.g. the 'Book of James') or contemporary sources such as the Bestiaries, the 'Golden Legend', or from the lives (real and legendary) of the saints.[13]

In an age when the oral tradition and moralistic story-telling were still strongly in evidence and literacy was the prerogative of the few (due as much to the lack of books and education as to ignorance), it was only natural that the Bible story itself should also be presented in a visual form. This gave rise to the narrative cycles that became an essential part of Christian art in the west, bringing to life the mysteries of the Creation, the Incarnation and the Resurrection. But a symbolic imagery which, by its very nature, hangs suspended somewhere between heaven and earth, maintains a precarious balance. On the one hand there is the view, shared by Dionysius and Suger, that 'the dull mind rises to the truth through material things', while

on the other is that of St. Bernard of Citeaux, founder of the Cistercian Order. The latter, while admitting that 'since the devotion of the carnal populace (the laity) cannot be incited with spiritual ornaments, it is necessary to employ material ones',[14] saw the potential risks in the 'descent' into the world that accompanied the material representation of the divine mysteries: 'What avail these comely forms in places where they are defiled with customary dust?'[15] He also expressed his concern regarding the potential diversion from their spiritual duties that these carved and painted images, particularly the more fantastic zoomorphic examples, created for encloistered monks, 'So many and so marvellous are the varieties of divers shapes on every hand, that we are more tempted to read in the marble than in our books, and to spend the whole day in wondering at these things rather than in meditating the law of God'.[16]

In their own way these two views sum up the permanent and paradoxical dilemma of religious symbolism in general, and of Christian symbolism in particular. On the one hand, the purpose of the symbolic imagery of the medieval cathedrals was the 'ascent' of man towards spiritual truths; on the other, the 'descent' of those same truths into material form ran the risk of becoming earthbound. It could fulfil its purpose as long as it hovered mid-way between heaven and earth, at a point where ascent and descent were sustained in harmonious balance. If it soared too high, it would be beyond the reach of mortal man; if it dipped too strongly towards the earth, it might have difficulty in rising again.

Outwardly the symbolic imagery of the medieval cathedrals may appear as essentially didactic, there for the instruction of 'the poor'. For those responsible for building them, however, the real mysteries were expressed in the architecture: beneath its surface sculpture there vibrates a deeper resonance.

THE SYMBOLISM OF NUMBERS

'The Divine Wisdom is reflected in the numbers impressed upon all things . . . The science of numbers is the science of the universe and the key to its secret.' The numbers referred to

here by St. Augustine are not the same as those we might use on a pocket calculator. He is referring to the work of the Creator as the Divine Geometer, and the perfection of the divine order reflected in the harmonious patterns that permeate the universe. It was the Greek desire to find this 'uniformity in the multiplicity of phenomena'[17], this 'music of the spheres', that led men such as Pythagoras and Euclid into developing the system known as 'geometry' (Greek: 'geo-' = earth; 'metron' = measure), which has in turn fascinated man across the centuries. In more ways than one, the fascination of geometry lies in the sense of self-discovery that accompanies working with numbers at this level. Professor Kitto expresses how the experience affected him: 'It was with great delight that I disclosed to myself a whole system of numerical behaviour of which my mathematical teachers had left me (I am glad to say) in complete ignorance . . . They had never told me, and I had never suspected, that Numbers play these grave and beautiful games with each other, from everlasting to everlasting, independently (apparently) of time, space and the human mind. It was an impressive peep into a new and a perfect universe.'[18] The discovery of the geometric laws of the universe commingled with Christian symbolism in the architecture of the great churches and cathedrals, in what is known as 'sacred geometry' (see below).

The significance of numbers in expressing the divine order of things or the invisible forces at work in the universe was not, however, restricted to the Greeks and geometry. It was also apparent to those who handed down the tradition of the Kabbalah, 'the inner and mystical aspect of Judaism'. The interpretation of Kabbalistic scripts is according to the letter-code of the Hebrew alphabet, in which each letter represents a specific number. Again, 'these numbers are not to be considered in their arithmetical sense. Each one, in fact, signifies an aspect of living forces at play in the Universe; and the text is intended to project these forces into our very being, thus acting as a Revelation.'[19] When applied to the Kabbalistic passages in the Bible, for example the story of the Creation related in the Book of Genesis, the intended inner or symbolic meaning becomes apparent. A similar, Greek system, or *gematria*, has been applied to the New

Testament.[20] But such systems were not open to everyone: their apparent obscurity to us is due both to the distance of time and their initiatic transmission. Furthermore, the translation of the Bible into other, more modern, languages has not always been able to retain the subtleties of the original Hebrew or Greek. Nevertheless, the sometimes frequent ocurrence of certain numbers in both the Old and New Testaments is not by chance.

The symbolic relevance of numbers as an expression of the 'intuitive impulse of harmonious nature' extends beyond geometry and language into other spheres: music, architecture, and symbolic ritual each seek 'to bring order ... to give form to the formless, symmetry to the chaotic mass.'[21] Even though the deeper significance of numerical symbolism may not be immediately apparent to the observer, its harmonious presence, like that of the divine order which inspired it, can touch him or her in a manner that escapes rational explanation. This is particularly true in the way in which we may be affected by a certain sequence of musical notes, or the lofty proportions of a church interior. For example, while the proportions of King's College Chapel, Cambridge, rely on sacred geometry there is also a subtle visual repetition of the number 26 in its windows and interior architectural detail (i.e. 26 great stained-glass windows, etc.). The recurrence of this number is linked to the Hebrew YHWH,[22] the unutterable name of God which, in the symbolic letter-code, is represented by that same number. The Name, YHWH (carved above the west door), is thus embodied in the building.[23]

SACRED GEOMETRY

We have already encountered the image of God, the Divine Geometer or Divine Architect, compass in hand, creating the universe (see Chapter 2, 'Microcosm and macrocosm'); an image inspired by the biblical verse: 'Thou hast arranged all things by measure and number and weight.'[24] This symbolic image was reinforced by the biblical passages describing the precise form and dimensions of certain structures: Noah's Ark (Gen. 6:15–16), the Ark of the Covenant and the Tabernacle (Ex. 25:

10–27:18), the Temple of Solomon (1 Kings 5:5–7:51) and the Heavenly City or New Jerusalem (Rev. 21:10–21). Of these it was the dimensions of Solomon's Temple which held a particular fascination for the medieval theologians and architects, for in approaching the church building as an image of the Heavenly City they turned to it as a prefigurative model.[25] In turn it was to provide a crucial link between Christian architecture and the divine harmony or 'music of the spheres' expressed through numbers.

The connection between music and number had been made by Pythagoras through his discovery that there was a direct correspondence between the harmony of a sequence of musical notes and a series of mathematical ratios. Briefly, a single stretched string vibrating along the whole of its length produces a basic note which is translated into the ratio 1:1. If the string is then shortened to half its length (the ratio 1:2), the same note is produced an octave higher. Further harmonic variations of the basic note correspond to the ratios 1:3, 1:4, etc. The geometer, by formalizing the perfect consonances, had arrived at what he considered to be the 'perfect proportions' underlying the natural structure of the universe. It was natural for the Greek mind to reason that what was pleasing to the ear must also be pleasing to the eye and so a way had been found for man to reproduce in visual terms the 'music of the spheres'. If the architect designed his building according to these proportions, it would resonate in harmony with the universe, thus reflecting the divine order. The particular relevance of this for Christian architecture came when it was realised that the dimensions of Solomon's Temple, the model for the Heavenly City, corresponded to the perfect proportions.[26]

This reflection of the divine order is, in essence, the theoretical principle of 'sacred geometry'. It brings together the material and the spiritual worlds in such a way that while we may not be overtly conscious of it, we are affected by it just the same. In its practical form it applies the 'perfect proportions' to the basic geometric figures of the circle, the square, and the triangle; and to the variations that arise from them, the rectangle, the sphere, the cube, etc. These, too, have

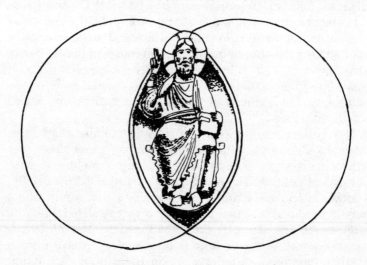

Figure 5. Christ in a vesica piscis

their own symbolic value (see Appendix). One of the most fundamental figures of sacred geometry is, however, the *vesica piscis*, also known as the mandorla. In essence it appears as the almond-like shape created when two circles overlap each other. In practice it is the starting point from which the two circles are drawn and therefore symbolises the 'point' at which apparently separate forces or worlds simultaneously divide and meet.

ALCHEMY[27]

At first glance a connection between alchemy, with its search for the 'Elixir of Life' and the 'Philosopher's Stone', and Christianity may appear incongruous. This is largely due to the natural suspicion or superstition surrounding anything that appears, on the surface at least, to dabble in the obscure or 'occult' sciences; but it is also due, in part, to its frequent use of tangential language in order to conceal its profound inner nature. Outwardly, that is, in its practical form, alchemy presents itself as metallurgy – the transmutation of base metals

into gold. The outer alchemical method, however, corresponds to an inner spiritual process – the transformation of man into a spiritualised being. In a Christian context, the Philosopher's Stone, which turns base metals into silver and gold, is in reality nothing other than a symbol for Christ.[28]

The alchemical process itself is traditionally divided into the 'lesser' and 'greater' work, each consisting of three stages. As Titus Burchkhardt explains, 'The first three stages correspond to the "spiritualisation of the body", the last three to the "embodying of the spirit", or the "fixation of the volatile". Whereas the "lesser work" has as its goal the regaining of the original purity and receptivity of the soul, the goal of the "greater work" is the illumination of the soul by the revelation of the Spirit within it.'[29] These six stages plus a seventh stage which is not included as part of the work may be seen to correspond with the 'journey of the soul', representing the ascent of the soul and the descent of the spirit: the alchemist's symbolic crucible in which the work is carried out being the human body. Each stage is dominated by one of the seven major planets or planetary signs, the completion of the 'work' being expressed by the sign of the sun.[30] The link between alchemy and Christian symbolism found its expression in the cosmological symbolism of the great medieval cathedrals, presenting the relationship 'macrocosm – microcosm' through the latter's identification with the 'body' of Christ and man; a relationship which also expresses the divine unity underlying the apparent diversity or multiplicity of the material world.

Did those who initiated the symbolic link between the alchemic 'spiritualisation of the body' and Christ draw their inspiration from these words of St. Paul: 'Our commonwealth is in heaven, and from it we await a Saviour, the Lord Jesus Christ, who will change our lowly body to be like his glorious body, by the power which enables him even to subject all things to himself.'?[31]

THE END OF MEDIEVAL SYMBOLISM

In one sense it was its own mystical fervour that brought medieval Christian symbolism to an end. It soared so high

that its collapse was almost inevitable: like the desire of the Gothic architects to overcome the forces of gravity in building ever-higher vaults over the naves of their cathedrals, reaching its peak in the choir at Beauvais. The high stone vault erected there in the latter half of the thirteenth century had hovered for a few years at a height of 158 feet before falling to the ground. In spite of that, and however we may regard it now, the symbolism of the thirteenth century cathedrals remains a fitting monument to what has been described as 'a time of grace in the history of the Church of Christ in Europe.'[32]

There were, of course, many other factors that also precipitated its decline. The rise of humanism, a natural result of man's increased sense of his rightful place in the divine order of things, was concommitant with man's exploration of the physical nature of the universe. Gradually the almost mystical attitude towards the unity of the universe became divided up into a series of more pragmatic, down-to-earth disciplines – philosophic and scientific thought could no longer rely on the quantum leaps inspired by faith; they required practical proof as well. The invention of the printing press enabled the Holy Bible to become a printed book rather than being painstakingly handwritten, thus reaching a wider public; but its translation into national languages (English, French, German, etc.) eroded the unity of language the Western Church had enjoyed up to that time.

In concluding his book on thirteenth century religious art in France Emile Mâle turns to the words of Victor Hugo to express this demise of symbolic expression: 'In the Middle Ages men had no great thought that they did not write down in stone . . . the Gothic sun set behind the colossal press at Mainz.'[33]

4 · TYPOLOGY: THE OLD AND NEW TESTAMENTS

The Old Testament is nothing but the New covered with a veil, and the New is nothing but the Old unveiled.

St Augustine.

WHAT IS TYPOLOGY?

'Typology' is the use of 'types' and 'antitypes' in which a 'type' (Greek *tupos* = stamp or mould) has a corresponding image or impression, the 'antitype'. In biblical typology the 'type', an idea, person, or event in the Old Testament, prefigures its 'antitype', a corresponding idea, person, or event in the New Testament. In this way the prophetic or symbolic value of the 'type' is both confirmed and revealed in its 'antitype'. In the earliest days of Christianity, before the writing of the Gospels and compilation of the New Testament, the followers of Jesus saw in the Old Testament many such prophetic references which they regarded as alluding to his coming. Jesus himself was to reveal the message of God it contained for all mankind and the subsequent events of his life and many of his words

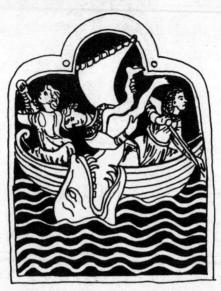

*Figure 6. Jonah and the Whale, after Nicholas of
Verdun (12th century)*

recorded in the Gospels (Old English: 'the Good News') serve
as a further 'unveiling' of these references, some of which
receive additional clarification in the Letters or Epistles.

There is therefore a binding relationship between the two
Books of the Holy Bible, a relationship which may be explored
in a number of ways. They may be approached like the two
panels of an open diptych: the picture on each panel being
such that it may be treated independently of the other,
or even become separated from it; and yet, through their
essential conjunction, both panels also simultaneously justify
and complement each other. It is in this way that Christian
art often juxtaposed two related scenes, either side by side in
close proximity, for example in a stained glass window, or as
pendants to each other within the overall design of a church
building. Alternatively, the Old may be seen to contain the
New, the significance or meaning of the former having been
revealed through the coming of Jesus Christ. In this case it was
sufficient to depict the scene of Jonah and the Whale to imply
its antitype, the Death and Resurrection of Christ. Yet again,

the two parts may be taken consecutively, the New Testament being regarded as the full realisation of God's plan which has been progressively revealed in the Old.[1] To illustrate this we can take a brief look at the type just referred to – Jonah and the Whale.

JONAH AND THE WHALE

The example of Jonah and the Whale as a type of the Death and Resurrection is given by Jesus in response to a request from the Pharisees for a sign: 'An evil and adulterous generation seeks for a sign; but no sign shall be given to it except the sign of the prophet Jonah. For as Jonah was three days and three nights in the belly of the whale, so will the Son of man be three days and three nights in the heart of the earth.'[2] The connection should be clear to us, particularly with the benefit of hindsight in knowing that Jesus himself is the 'Son of man' who spent 'three days and three nights' in the tomb. For the faithful Christian this was not merely a case of history repeating itself; having become one with Christ through his baptism the typology had a personal meaning for him as well.

THE VEIL

A veil* may fulfil several functions but in its symbolic context in the Bible it is generally used in the sense of concealment, whatever lies behind the veil remaining a mystery until the moment of revelation when the veil is drawn aside or removed. In giving Moses instructions in the making of the Tabernacle God tells him, 'You shall make a veil . . . and bring the ark of the testimony in thither within the veil; and the veil shall separate for you the holy place from the most holy.'[3] Later, when Moses receives the words of the covenant, the Ten Commandments, he spends 'forty days and forty nights' on Mount Sinai in the presence of the Lord. When he descends to rejoin the Israelites his face shines so brightly that they are afraid to come near him. After giving them 'in commandment' what God had told him, Moses covers his face with a veil which

43

he removes again each time he speaks with God.[4]

The veils of the Old Testament are drawn aside by Christ to reveal a new understanding of the relationship or covenant between man and God. The veil that separates 'the holy place from the most holy' in the Temple at Jerusalem, in itself the Jews most holy shrine, is torn open at the moment of Jesus' death; that is, what was previously veiled from man is revealed through the Death on the Cross. 'And Jesus cried again with a loud voice and yielded up his spirit. And behold, the curtain of the temple was torn in two, from top to bottom.'[5] The significance of this is expanded by St. Paul, '. . . through the greater and more perfect tabernacle (not made with hands, that is, not of this creation) he [Christ] entered once and for all into the Holy Place, taking not the blood of goats and calves but his own blood, thus securing an eternal redemption.'[6] In the next chapter there is a word of explanation connected with this regarding the sacrifice of animals: 'When Christ came into the world, he said, "Sacrifices and offerings thou hast not desired, but a body hast thou prepared for me . . . Lo, I have come to do thy will". He abolishes the first [animal sacrifice] in order to establish the second. And by that will we have been sanctified through the offering of the body of Jesus Christ once for all'.[7] A further reference to the 'veil' follows, emphasising the redemptive nature of the sacrifice on the Cross, 'We have confidence to enter the sanctuary by the blood of Jesus, by the new and living way which he opened for us through the curtain [the veil], that is, through his flesh.'[8] As for the veil with which Moses covered his face, 'to this day when they read the old covenant, that same veil remains unlifted, because only through Christ is it taken away. Yes, to this day whenever Moses is read a veil lies over their minds; but when a man turns to the Lord the veil is removed.'[9] In the context of this last quotation the 'veil' can also be taken to represent the human mind.

THE OLD AND THE NEW

Taken symbolically, the removal of the veil bringing new life to what was 'old' is a useful analogy to keep before us when

exploring other typological references. It serves to indicate that what is revealed is already present *in potentia* in the first place, but the veil conceals its real fullness. As we are reminded by the words of Jesus Christ, 'I say to you, before Abraham was, I am.'[10] And by St. John: 'In the beginning was the Word . . . He was in the world, and the world was made through him, yet the world knew him not . . . And the word became flesh and dwelt among us, full of grace and truth . . . And from his fulness have we all received, grace upon grace. For the law was given through Moses; grace and truth came through Jesus Christ.'[11]

For many, Jesus Christ was the fulfilment of the prophecy contained in Jeremiah: 'Behold, the days are coming, says the Lord, when I will make a new covenant . . . I will put my law within them, and I will write it upon their hearts . . . for they shall all know me, from the least of them to the greatest . . . for I will forgive their iniquity, and I will remember their sin no more.'[12] The distinction between the 'old' and the 'new' covenant is extended symbolically in a variety of ways; for example, darkness and light; flesh and spirit, death and life, etc. The 'old' is also referred to in more oblique language, becoming 'this generation', 'the dead' 'the blind', 'the maimed', etc. Sometimes the words 'first', and 'second' or 'last' are used to convey a similar idea. One of the most powerful images to use this terminology in explaining the nature of the resurrection comes from St. Paul. It has given rise to Christ being referred to as the Second Adam.

THE SECOND ADAM[13]

In St. Luke's Gospel the genealogy of Jesus begins with the words: 'Jesus, when he began his ministry, was about thirty years of age, being the son (as was supposed) of Joseph, the son of . . .' and ends with, 'the son of Adam, the son of God.'[14] This lineage reminds us of the common heritage that is shared by both Adam and Christ: they are both 'sons of God', but the difference in the nature of their being is expressed in a passage by St. Paul (which, perhaps, brings back to mind the idea of the 'veil' and the sentence: 'He abolishes the first in

order to establish the second.'): 'Thus it is written, "The first man Adam became a living being"; the last Adam became a life-giving spirit. But it is not the spiritual which is first but the physical, and then the spiritual. The first man was from the earth, a man of dust; the second man is from heaven. As was the man of dust, so are those who are of the dust; and as is the man of heaven, so are those who are of heaven. Just as we have borne the image of the man of dust, we shall also bear the image of the man of heaven. I tell you this, brethren: flesh and blood cannot inherit the kingdom of God, nor does the perishable inherit the imperishable.' (vv. 45–50). These last words return us to the point St. Paul had made earlier in the chapter, when making his initial juxtaposition of Adam and Christ: 'For as in Adam all die, so also in Christ shall all be made alive. But each in his own order . . .' (v. 22).

The image of Christ as the Second Adam, come to redeem the sin of the first, received further, symbolic expansion when it was woven into the 'Legend of the True Cross'; a popular legend which linked the Tree of the Fall to the Cross of the Crucifixion.

THE LEGEND OF THE TRUE CROSS[15]

Although the 'Legend of the True Cross' and the subsequent events of its 'Finding' or 'Invention' are not directly related to the biblical Scriptures they provide an illustration of the belief held in the miraculous nature of the Cross. They also serve to underline the significance of Christ's Crucifixion, not only in its historical context but for all 'time'.

There are several versions of this medieval legend which, while differing from each other in their detail, share the same central theme – the seed that is planted in the ground with the dead Adam provides the wood for the Cross of Golgotha. The colourful legend, nurtured by the creative spiritual imagination of the Middle Ages, weaves together essentially Christian themes with a wider symbolism taken from outside the realm of conventional Christian thought. In this way the universal relevance of the Crucifixion is demonstrated through its expression in the broader context

of universal symbolic myth. For example, the symbolism of the Cosmic Tree, the *axis mundi*, and the Centre become synonymous with the Cross. In the 'Legend' the dimensions of time and space are brought together in a story which is comparable to man's 'pilgrim life on earth' and the hazardous, wandering journeys undertaken by the great mythical heroes, such as Ulysses, as they seek to return to their spiritual source. Like these heroes the wood of the Tree undergoes a series of ordeals or adventures which together constitute a process of transformation; a process that expresses itself through a wealth of symbolic references. (See Glossary: Cross, Pillar, Water, etc.)

The legend, beginning with Adam's disobedience of the Divine Will and ending with man's redemption on the Cross through the Crucifixion of Christ, the Second Adam, unfolds through time and space in a linear progression but, in the end, we are brought back to the point at which we began. Time and space have travelled full cycle. In returning to the point of departure, however, the normal 'linear' concept of these dimensions is removed and replaced by one eternal point which is simultaneously both the beginning and end of time. Golgotha, 'the place of the skull', where the Cross is erected for the Crucifixion, is also the site where the Tree from which the Cross was made first took root. The skull of Golgotha is none other than the skull of Adam in which the seed of the Tree germinated. The fruit of the Tree of the Knowledge of Good and Evil has been transformed into the Tree of Eternal Life, uniting the two Adams.

Before looking at the 'Legend' itself, it is worth referring back to some more words from St. Paul's passage on the resurrection: 'What you sow does not come to life unless it dies. And what you sow is not the body which is to be . . . God gives it a body he has chosen, and to each kind of seed its own body . . . What is sown is perishable, what is raised is imperishable. It is sown in dishonour, it is raised in glory. It is sown in weakness, it is raised in power. It is sown a physical body, it is raised a spiritual body. If there is a physical body, there is also a spiritual body' (vv. 36–44).

According to one version of the legend a seed from the fruit of the Tree of the Knowledge of Good and Evil sticks in Adam's

throat, the 'Adam's Apple'. Another version tells how an angel gives Seth, Adam's son, three seeds (from the Tree of Life), instructing him to place them under Adam's tongue when the latter is buried. The tree that grows from Adam's grave is linked with many incidents from the Old Testament. A small branch of it becomes Moses' miraculous rod with which he divides the Red Sea to liberate the Israelites from Egypt, strikes the rock in the wilderness to bring forth water, and on which he hangs the brazen serpent (a prefigurative type of the Crucifixion). The Tree is cut down for use as the central pillar in the construction of Solomon's temple but when it changes its length at will, in turn being either too short or too long to fit into the building, it is discarded and thrown into a stream of water where it floats up to the surface and becomes a bridge between the two banks. The Queen of Sheba, on her way to visit Solomon, recognises the true nature of the bridge and, refusing to walk across it, wades through the waters of the stream. The Tree, by now shaped into a wooden beam, is buried at the place where the miraculous pool of Bethesda is later dug. The lame and sick who either bathe in the pool or drink its waters are healed and made whole again. As the time approaches for the Crucifixion, the beam floats up to the surface of the pool where it is found and used to make the Cross of the Crucifixion.

It is at this point that time and space have travelled full circle. The seed of the fruit of the 'Tree of the Fall' that grew into the Tree of the Cross from Adam's grave has been shaped into the Cross of the Redemption and raised on the spot from which it first took root.

THE FINDING OF THE CROSS

Although the Cross disappears after the Crucifixion it re-emerges to play a decisive rôle in the establishment of the new religion of which it is the central symbol. History again borders on legend in furthering the inspiration drawn by man from the Cross and the strength gained from his faith in the risen Christ.

In 312 Constantine the Great advanced on Rome to capture it from his rival Maxentius. As he neared the city he prayed

to God to reveal to him who He was. To his own amazement, and that of his army, a cross of light appeared in the sky, accompanied by the sign *In hoc signo vinces* – 'By this sign shalt thou conquer'. That night he dreamed that an angel showed him the same sign, instructing him to use its likeness on his battle standard. This he did in the belief that the God of the Christians had revealed Himself to him as the One True God and had promised him victory over his enemies. In the ensuing battle of Milvian Bridge on the Tiber Constantine's army defeated the superior numbers of Maxentius, leaving him free to enter Rome as sole ruler of the western half of the Roman Empire.

This victory convinced Constantine of the power of the God worshipped by the repressed and persecuted Christians. As a result he had his coins decorated with the 'Chi–Ro' monogram and in the Edict of Milan (313) granted the Christians freedom of worship. His mother, Helena (later canonised), saw the Cross in a vision after her conversion and dedicated herself to discovering its whereabouts. 'The Finding (or Invention) of the True Cross' tells of a certain Judas who, after spending seven days without food in a dry well where he had been thrown by Helena, indicated where the Cross was to be found. The three crosses from Golgotha were dug up together and in order to find which was the True Cross they were placed in turn over the dead body of a young man. As the True Cross passed over him the young man was miraculously restored to life: further proof of the triumph over death revealed by Christ's own Death and Resurrection.

ASCENT AND DESCENT

The idea that earth and heaven, while appearing to be in some way separate from each other, are not inseparable frequently finds its expression in both the Old and New Testaments in the form of 'ascent' and 'descent'; that is, man's 'ascent' towards heaven is rendered possible by a corresponding 'descent' from heaven towards man. This 'descent' may manifest itself through the words of God, through the Spirit, or through angels. Man's 'ascent' may be conveyed through his dutiful

response to the words of God, through his being filled with the Spirit, or through his communication with God on mountain tops or other high places. The language of 'ascent' and 'descent' also corresponds to the 'journey of the soul', (referred to in Chapter 1), in which it receives its sustenance from the Spirit. In both these contexts man is unable to ascend heavenwards by his own efforts or devices; if he does try, he is building his own Tower of Babel!

Very early on in the Old Testament we are told the story of the Tower of Babel,[16] in which the people of the plain decide to build themselves ' a city, and a tower with its top in the heavens, and let us make a name for ourselves. . . .' When God sees what they are attempting to do he says, 'Behold, they are one people, and they all have one language; and this is only the beginning of what they will do; and nothing that they propose to do will now be impossible for them. Come, let us go down, and there confuse their language, that they may not understand one another's speech.' There are many possible interpretations of this story but the essential outcome is the same: man's attempt to ascend or raise himself up by his own efforts results in confusion and his inability to understand his fellow men which, in turn, can lead to man being at odds with himself.[17] The confusion of language and lack of understanding which befalls man as a result of this episode is reversed by the descent of the Holy Spirit to the twelve apostles at Pentecost: 'And they were all filled with the Holy Spirit and began to speak in other tongues, as the Spirit gave them utterance . . . and . . . the multitude came together, and they were bewildered, because each one heard them speaking in his own language'.[18]

ABRAHAM AND JACOB

The typology of the 'old and new' (see above) extends to the principal figures encountered in the foundation of the two covenants. Abraham, father of the Hebrew people, is regarded as a type of God the Father: the covenant between God and Abraham, the miraculous birth of his son (Isaac) to his wife (Sarah) and his willingness to sacrifice Isaac to obey God's

Will provide further types of the Nativity, Jesus, Mary and the Crucifixion.[19]

The miraculous birth of Jacob and Esau to Rebekah, Isaac's wife, may be regarded as the foundation of the two covenants, or the two Adams (see above): 'Two nations are in your womb, and two peoples, born of you, shall be divided; the one shall be stronger than the other, the elder shall serve the younger.'[20]

Jacob, re-named Israel, as the father of the twelve tribes of Israel is a type of Jesus and the twelve apostles. His dream in which a ladder was 'set up on earth, and the top of it reached up to heaven . . . and the angels of God were ascending and descending on it'; his anointing of the stone and the setting up of the sanctuary at Bethel provide further links with the establishment of the covenant.[21] The removal of the stone from the well in order to feed the flocks of his own family, instead of waiting 'until all the flocks are gathered together'[22] indicates the partial revelation of the Old Covenant, contrasting with the New Covenant conveyed to all men when the stone is removed to reveal the empty tomb.

FURTHER TYPOLOGY

Because of the common ground shared by the two Covenants the typological references abound. The events of the Exodus from Egypt by the Israelites provide several easily identifiable types, including the following: the Passover lamb = the Paschal Lamb; the forty years in the wilderness = the forty days in the wilderness; manna, the food from heaven = Christ, the living bread; Moses and the brazen serpent = the Crucifixion and Redemption; Moses striking water from the rock = Christ, the living water.

Origen, the third century theologian, draws attention to the correspondence between the forty-two stages of the Israelite's journey from Egypt to the borders of the Promised Land and the forty-two descendants of Jesus, linking it with the stages of the ascent of the soul and descent of the Spirit.[23]

Of further interest are the references to 'Egypt' and 'Jerusalem' in both the Old and New Testaments. 'Egypt'

can be interpreted as 'the world' or starting-point of the soul's journey in both Testaments; 'the Temple in Jerusalem' can be understood as the goal of the soul in the Old Testament while the 'New Jerusalem' or 'the Kingdom of Heaven' represent the end of the soul's journey in the New.

5 · THE LIFE OF CHRIST (1)

'You are from below, I am from above; you are of this world, I am not of this world.'[1]

THE PARABLES

In coming to the Life of Christ as it is written in the Gospels we encounter a truly symbolic language, expressing events whose profound mystery is conveyed through the language of the events themselves – events which take place 'in' this world but, by their very nature, are not 'of' this world. We are given an indication of this in Jesus' own explanation of the Parable of the Sower,[2] which is also, in one sense, a parable about parables. 'I speak to them in parables, because seeing they do not see, and hearing they do not hear, nor do they understand.' As he explains to his disciples: the seed sown by the sower is the word of God and each of the four sowings presents a different stage in the listener's ability to 'hear' it. In other words, he provides us with a series of gradations illustrating the difference between simply 'listening' to the word and 'hearing' the profundity of its message. In the parable itself the four gradations or sowings correspond to the four traditional levels of interpretation for biblical texts and symbols outlined

previously in Chapter 2: the literal, allegorical, moral and anagogical. As he gives his explanation of the parable Jesus guides us beyond the outer or literal understanding and on to the second, allegorical level. It is then left up to us, the listener, to 'hear' the more profound content of the word for ourselves by either lifting or opening up our hearts to receive it.

The parables of Jesus are an example of the ancient use of stories as vehicles for spiritual teaching. In their transmission from person to person or their telling and re-telling in religious communities they carried with themselves something else which was beyond the actual words and, as with all story-telling traditions, the listener actively worked to hear what this was, not being satisfied until he had extrapolated from it what he perceived to be its innermost meaning. Even then he would go on to further interpretations because the levels of meaning contained within each of these stories is infinite, seemingly changing as our own circumstances change.

'THE HOUSE NEXT DOOR'

In an earlier chapter Alan Watts' description of the two ways to get to 'the house next door' was mentioned in connection with the *via positiva* and the *via negativa* or the active and contemplative lives. In a wider context the two ways are also examples of man's search for spiritual fulfilment. Sometimes he may have to go around the world in the literal sense or through the major part of his life before he is actually able to turn to God at a profound inner level, acknowledging the gift of the spirit bestowed on him many years before. The same applies to the person who only has to take the necessary two or three steps to achieve the same fulfilment; it may in reality be several years before he is able or ready to take those few steps. In effect, the journey to 'the house next door' can be seen as the journey towards spiritual union – an inner pilgrimage or voyage to the centre of the maze. In this sense it is the return to our true home where the Father waits with loving patience for our home-coming.

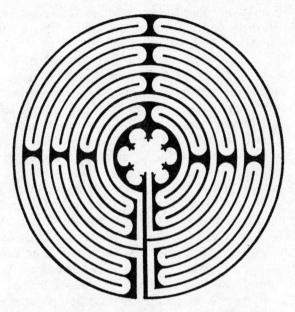

Figure 7. The Maze, from Chartres Cathedral

THE PARABLE OF THE PRODIGAL SON

The parable of the Prodigal Son[3] has many interpretations, one of which may be taken as an example of this journey to 'the house next door'. In the parable a certain father has two sons, one of whom takes his leave and his birthright and sets off into the world. His journey to a 'far country' can be interpreted as a turning away from God, his squandered inheritance implying the wastage of his spiritual gifts. The famine that follows represents a turning point for him. Driven by his starvation he works in the fields, prepared even to eat the food given to the pigs, but 'no one gave him anything'. The famine represents an inner awakening, caused by his starvation of real, that is, spiritual, food. Driven by this hunger he turns to the nearest available source which is with the pigs in a field, signifying his search in the world for the food he requires. The world, however, cannot give him what he needs and so his thoughts turn to home and his own father's servants who are all well-fed. This is a further, deep awakening

which is followed closely by yet another as he actually makes the decision to return home to his father. This decision is his repentance, a turning away from the ways of the world towards a source that is above it. It is also a decision which is made in great humility for, as the son says, 'I am no longer worthy to be called your son; treat me as one of your servants.' The humility of his decision lies in his willingness to return home as a servant, not as a son. To return as a son would be to expect his father to feed him; to go as a servant is to know how to be grateful for even the smallest morsel of food.

The journey home is a long one and when he is 'yet at a distance' he finds his father running to meet and embrace him; an event which reminds us that sometimes we have to travel a very long way away from God in order to recognise our need for him. When we do finally acknowledge this need we find him there, already waiting for us with open arms. But what of the second son? He has apparently 'heard' nothing in the intervening years, even though he remained physically close to his father. His angry refusal 'to go in' and participate in the feast given in celebration for the return of his lost brother suggests that he is not ready to take the few steps to reach the house. His all-seeing and compassionate father, sensing this, goes out and entreats him to come in – but the parable ends without telling us whether or not the second son enters the house; and it also leaves it for us to decide which of the two descriptions of the sons comes closest to being a description of ourselves.

In examining the parable a little further it becomes clear that the inner openings or awakenings referred to are really gifts of the grace or love of God, extended to the wayward son in order for him to return home. In that respect even the disastrous famine he suffers can be interpreted as a 'gift', as it leads him to return to the loving father he had forsaken.

JESUS THE HEALER

The great compassion of the father in the parable of the prodigal son is also found in the accounts of Jesus' work as

a healer. This aspect of his ministry contains an extraordinary catalogue of healing, for here is a man who enables the blind to see, the deaf to hear, the dumb to speak and the lame to walk. He also cleanses lepers, casts out demons and brings the dead back to life. The news of his remarkable powers of healing spreads rapidly, drawing even more of the sick and suffering to him, sometimes with the hope that merely being in his presence or touching his garments will be sufficient to bring about their cure. In these latter instances Jesus often concludes his healing with the simple words, 'Your faith has made you whole'.

In the same way that Jesus provides us with an explanation for his talking in parables, he also reveals to us the source of the power by which he heals. In a passage following his temptation in the wilderness we find: 'And Jesus returned in the power of the Spirit into Galilee . . .' There he enters the synagogue in Nazareth on the Sabbath and is handed the Book of Isaiah to read from. The passage he reads is a prophecy of his own Messianic mission on earth: 'The Spirit of the Lord is upon me, because he has anointed me to preach good news to the poor. He has sent me to proclaim release to the captives and recovering of sight to the blind, to set at liberty those who are oppressed, to proclaim the acceptable year of the Lord.' After closing the book he tells those in the synagogue, 'Today this scripture has been fulfilled in your hearing.'[4] The essence of the passage is that Jesus is 'the Anointed One' (Greek: *Christos*). His own name 'Jesus' also conveys the nature of his mission for it can be translated as 'Saviour', the salvation he brings being by means of the power of the Spirit invested in him. The condition of the people he has come to save indicates that they are experiencing, in one form or another, a need of the healing power the spirit provides.

THE GERASENE DEMONIAC

There are many dramatic examples of Jesus' healing but one which uses a particularly symbolic language to explain the inner nature of the outer event is that of the Gerasene

demoniac.[5] When Jesus steps out of his boat he encounters a demoniac who lives among the tombs. The demoniac, who has an unclean spirit, has been chained and fettered many times but has broken free so often that 'no one could bind him any more' and even chains now no longer hold him. He cries out in his torment 'night and day among the tombs and on the mountains ... and bruising himself with stones'. The extreme nature of his sickness is indicated by the name of the unclean spirit, 'My name is Legion; for we are many'.

The description of the man's behaviour may be interpreted as the symptoms of his extreme inner conflict as his 'worldly' body struggles in order not to yield up its power to the spirit. On the one hand are the binding and dark symbols of man's life governed by 'the world' – chains, fetters, tombs and night; on the other are the symbols of the freedom and light that comes with man's ascent away from the world towards the spirit – the unbound man, the light of the sun and the high mountains. The stones with which he bruises himself reflect his torment, but they also imply that instead of harming himself with inanimate stones his real need is for 'the bread of life'. From the outer symptoms it would appear that the demoniac is experiencing what is sometimes referred to as the 'anguish of the soul', which occurs in its intense yearning for the spirit. When Jesus heals the man by releasing him from his torment the unclean spirit reveals its own nature by begging not to be 'sent out of the country'. That is, it enters the pigs – in themselves regarded by man as one of the lowest of creatures – which then plunge down a steep bank into the sea and are drowned. In other words, the unclean spirit goes back to the 'waters of the deep', the symbolic primordial chaos.

At the end of the account of the same event in St. Luke the healed man begs with Jesus to be allowed to remain with him, but Jesus tells him, 'Return to your home, and declare how much God has done for you,' and the man goes off 'proclaiming throughout the whole city how much Jesus had done for him,' – the 'city' standing here for the dwellingplace of men who are still enmeshed in the world.

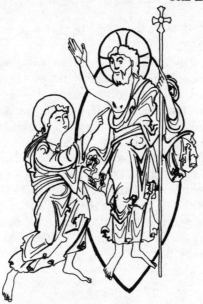

Figure 8. Doubting Thomas, from a 10th century
manuscript

FAITH

Of all the miraculous healings effected by Jesus the simplest
ones are often those in which the sufferer has been brought to
him through faith; that is, their faith in Jesus' power to cure
them of their suffering. This brings us back to the two ways to
arrive at 'the house next door'. Whether it arises out of a period
of suffering or from what is sometimes described as a quantum
leap, or in yet another way, 'faith comes from what is heard.'[6]
Faith is the gift of grace which enables man to say 'Yes!' It is
a Yes which frees man from his worldly bonds. There is no
vacillation: 'for one must not suppose that a double-minded
man, unstable in all his ways, will receive anything from the
Lord.'[7] Or, as St. Paul says in expressing the same idea, 'Do
I make my plans like a worldly man, ready to say Yes and
No at once?' 'Jesus Christ ... was not Yes and No; but in
him it is always Yes. For all the promises of God find their
Yes in him. That is why we utter the Amen through him, to

the glory of God.'[8] To say 'Yes' in this way is 'to say Yes to God's revelation'.[9]

Taken on its own like that 'faith' may appear to have little to do with symbolism but, in Christian symbolism at its most profound level, it is the very essence of it. In his Letter, St. James tells us, 'faith by itself, if it has no works, is dead.'[10] If we understand faith as coming from God, then we may regard 'works' as being what man does with it. That is, in his life; and that means in 'life as a symbol' (see Chapter 2, 'The meeting point of time and space'). To regard life in this way is to serve the Creator, not the creature. It is to turn to God by holding in one's heart the words from the Lord's Prayer, 'Thy will be done.'[11] And, by repeating those words, we echo the words of Jesus' own prayer on the Mount of Olives, 'Father . . . not my will, but thine be done.'[12]

PETER

When, as in the above context, life becomes a symbol, what we might call 'normal' symbols – that is, symbolic objects or events which we interpret or give meaning to – cease to exist. Instead of one thing being seen as simply representing another thing, it becomes synonymous with it. This is the case, for example, with Simon Bar-Jona; he does not merely stand for the rock on which the church will be built, he becomes 'the rock' when Jesus gives him the name Peter. In our modern Western world the importance attached to the giving of a name has largely been lost but, in other times and other cultures, a name fitted the essential character of a particular individual. This could function in one of two ways: either it fitted the 'persona' the individual already possessed, or it furnished him with one 'in potentia' which was there for him to grow into. In this respect, the naming of Peter is of especial interest; not merely because 'Peter' or *Cephas* means 'rock', but also because of the character of the man worthy of bearing that name.

Peter has a very human streak in him. While fervently believing in the divine nature of Christ and his mission in the world, he is also portrayed as seeing these in relatively

human terms until the moment when the fullness of the divine mystery is revealed to him. For example, when he had started to walk across the water towards Jesus a wind had risen and, overtaken by fear, Peter had begun to sink. Jesus reaches out a hand to save him, saying, 'O man of little faith, why did you doubt?' The events surrounding the naming of Peter provide a similar contrast between, on the one hand his profound faith, and, on the other, his very human passions. He receives his name when he recognises Jesus as 'the Christ', a fact that could only have been revealed to him by God; 'flesh and blood' not having the power to perceive such things. And yet soon afterwards Jesus rebuffs him, saying, 'Get behind me, Satan! You are a hindrance to me; for you are not on the side of God, but of men.' The reason for this rebuffal is that Peter, hearing Jesus talk of the suffering he must face, had reacted on a human level out of his concern for the physical safety of his master: 'God forbid, Lord! This shall never happen to you.'[13] Peter's human concern dominates again, this time out of respect for his master's position, when Jesus washes the disciples' feet. He understands the outer or literal form of the action rather than its inner significance. At first he protests, to which Jesus answers, 'What I am doing you do not know now, but afterward you will understand.[14] (See Chapter 6, 'The washing of the disciples' feet').

A similar exchange takes place as Jesus informs his disciples of his imminent departure from them, 'Where I am going you cannot follow me now; but you shall follow afterward.' Peter's response, 'Lord, why cannot I follow you now? I will lay down my life for you,' is answered by Jesus' prophecy of Peter's denying him three times before the cock crows.[15] When Peter hears the cock crow, the realisation that he had denied his master, the Christ, must have devastated him; particularly when we bear in mind two other prophecies which can be related to this occurence. The first had followed immediately after the 'Satan' rebuffal: 'If any man would come after me, let him deny himself and take up his cross and follow me . . . For whoever is ashamed of me and of my words . . . of him will the Son of man also be ashamed.'[16] The second had concerned the state of watchfulness man needs to maintain with regard to the

coming of 'that day': 'Watch therefore – for you do not know when the master will come, in the evening, or at midnight, or at cockrow, or in the morning – lest he come suddenly and find you asleep[17] . . .' 'And he (Peter) broke down and wept.'[18]

In contrast to the triple denial prior to the Crucifixion, Peter is able to give a triple affirmation when he sees his risen Lord standing at the edge of the sea. The significance of these three denials and affirmations may be increased when we recall the tripartite division of man. Peter's denial is one of total despair as his mortal perception of the divine Christ sees the impending death on the Cross as final. This Adamic perception of the finality of death is, however, torn aside like a veil when he sees his risen Lord. Each level at which he affirms his love for his Lord is rewarded with a corresponding command which, by degrees, gives him total charge of the Lord's flock: 'Feed my lambs . . . Tend my sheep . . . Feed my sheep.' The final command is 'Follow me.'[19]

6 · THE LIFE OF CHRIST (2)

In the beginning was the Word,
and the Word was with God,
and the Word was God . . .
. . . And the Word became flesh and dwelt among us.[1]

The opening verses of the Gospel according to St. John pronounce the mystery of the Incarnation in a truly poetic form, using the language and vocabulary of man to express what is, in its ultimate essence, beyond man's rational comprehension. As such they share a common ground with other works of sacred scripture in that they stand at the meeting-point of the earthly and heavenly worlds. To put this another way, the actual words may be the work of man, but their meaning and message is the work of God. There is a similar correspondence between 'form' and 'function' in other manifestations of sacred expression such as ritual, architecture and art. With all these sacred 'arts' their form and function have become so closely interwoven that it is not really possible to distinguish in them the difference between what is 'of man' and what is 'from God'; and yet, as far as a symbolic interpretation of our own lives is concerned, such a distinction is necessary. The need for making this distinction is not to

deepen the chasm that may already appear to distance man from God; it is more for the purpose of separating respectively the work of the 'creature' from the work of the Creator. It is in this context that we may apply one interpretation of Jesus' instruction to 'render to Caesar the things that are Caesar's, and to God the things that are God's.'[2]

'I AM IN MY FATHER, AND YOU IN ME, AND I IN YOU'[3]

The idea that life itself is the key to the mystery that lies behind it is a recurring theme in the New Testament. For example, we encounter it in these words of Jesus: 'If any man would come after me, let him deny himself and take up his cross and follow me. For whoever would save his life will lose it, and whoever loses his life for my sake will find it.'[4] Their fuller significance is expressed in the words of St. Paul: 'I have been crucified with Christ; it is no longer I who live, but Christ who lives in me; and the life I now live in the flesh I live by faith in the Son of God.'[5] In the context of these quotations it is clear that the sense which is given to 'losing one's life' is a symbolic one. It is not an actual physical death, but the same kind of mystical death as that yearned for in the earlier quotation from Richard Rolle's 'Fire of Love' – the death which brings with it a new life in Christ. (See Chapter 2, 'Seeing beyond the symbol').

For the Christian mystic the events of the life of Christ are a mirror of his own spiritual evolution or transformation. It is this aspect of Christian symbolism that we shall go on to explore briefly in the rest of this chapter. In doing so we move from the second or allegorical level of the symbol into the more personal experience of the third or moral level. To some extent this requires the abandoning of the rationalising function of the human mind in order to make the necessary personal connection, but if this is not possible, the events described may at least be understood at the allegorical level, at the same time giving the reader a small insight into some of the more symbolic inferences of living a life 'in Christ'. In this respect, the truly universal nature of the Christian life is expressed by St. Paul with reference to his life 'under the law

of Christ': 'I have become all things to all men, that I might by all means save some.'[6]

JOHN THE BAPTIST

In taking up his cross to follow Christ, the Christian embarks on a path of self-denial which may be practised on an inner as well as an outer level. In both instances this process is essentially a turning away from the ways of the world to follow the way of Christ. As such, it involves what might be referred to as a number of little 'deaths' or awakenings which, like those described earlier in the Parable of the Prodigal Son, come as gifts through the grace of God. For example, if we regard John the Baptist in this way, he may be seen to represent an initial turning away from the Adamic perception of the world. He is the 'voice of one crying in the wilderness'.[7] He is 'the messenger' sent to 'bear witness to the light'. But, however powerful this initial awakening may be 'he is not the light'. As John himself reminds those who question him regarding who he is and where he has come from, 'No one can receive anything except what is given him from heaven . . . I said, I am not the Christ, but I have been sent before him.'[8]

In the course of man's spiritual evolution he is always faced with the temptation to attribute the gifts originating from heaven to another source; namely, himself. This is where Jesus' instruction about the things of 'Caesar' and the things of God becomes increasingly relevant. In turning towards God the Baptist tells us, 'He who comes from above is above all; he who is of the earth belongs to the earth, and of the earth he speaks; he who comes from heaven is above all.'[9] A sentiment echoed in St. Paul's words concerning the two Adams, 'the first man was from the earth, a man of dust; the second man is from heaven'. (See Chapter 4: 'The Second Adam'). The preparation for Christ proclaimed by John, 'He must increase, but I must decrease,'[10] is the voice crying in the inner wilderness of worldly man, it is an initial, sometimes barely perceptible, intimation of the coming of the new order that will replace the old. Whereas John baptises with water, he who comes after him baptises 'with water and the spirit'.

The Baptism of Christ is inseparable from the life of John the Baptist but, as it is also linked to the Baptism of the Christian into the body of the Church, it will be met with again in the final chapter.

THE VIRGIN BIRTH

So far this book has given only the briefest of mentions to the Virgin Mary. The beautiful and deeply moving symbolism of the woman who bears the title of '*Theotokos*', the mother of God, is too large a subject in its own right to be dealt with briefly, without detracting in some way from the honour which is duly hers.[11]

Although she is variously presented as the Queen of Heaven, the figure of the Mother Church or the Madonna and Child, it is above all her humility and purity which are central to her symbolic portrayal. In a mystical context these qualities represent a state of non-attachment to the world; a state in which, freed from the corrupting influences of the world of man, the mystic may feel himself impregnated by the Holy Spirit. In this sense Mary is analogous with the human soul, untainted by its contact with the body.

There is a painting by Fra Filippo Lippi in the Staatliche Museum, Berlin, entitled 'Adoration in a wood', which links the symbolic image of the Virgin Mary as the 'enclosed garden' with the symbolism of John the Baptist. According to St. Antonine we should cultivate 'the little garden of the soul' in order for the Christ-child to be born into it. In Filippo's painting the small figure of John the Baptist, 'the messenger', stands by a flower-strewn garden which has been cleared by felling the trees of a forest. It presents a visual image of the Baptist's own words, 'Even now the axe is laid to the root of the trees; every tree that does not bear good fruit is cut down and thrown into the fire.'[12] In the clearing itself are the Virgin Mary and the newly-born Christ, while above them are painted the dove of the Holy Spirit and the figure of God the Father. In the ascent of man's soul away from the gravitational pull of the world the way has been cleared for an awakening of man's spiritual awareness, an awakening which can only take place in

the state of inner purity and humility personified in the Virgin Mary. That is the state which corresponds to man's being in the world but freed from its corrupting influences, having set his mind towards the heavens. At a very profound level man turns to God, uttering silently the words of Mary, 'Let it be to me according to your word;'[13] words which themselves are echoed in the 'Thy will be done' of the Lord's prayer.

THE FLIGHT INTO EGYPT

The Massacre of the Innocents, which precipitates the Flight into Egypt, is the desparate attempt by Herod to overcome the threat of opposition by another potential ruler of his kingdom. In this he symbolises the struggle of man's worldly nature to ensure its continued dominance over the potential 'whole' man – but that which is born of the spirit is beyond the destructive rule of man's worldly nature. In this context, with Egypt representing the state of man's bondage in the world, the Flight into Egypt may be regarded as a further turning point in man's spiritual journey. Through becoming the servant of a higher, heavenly authority, man is released both from the rule of his worldly nature and from his bondage in the world. These different aspects are brought to fruition by the death of Herod himself, or the passing away of man's submission to the ways of the world, thus freeing him from any further bondage in 'Egypt'. In the images representing this event the donkey bearing the Mother and Child signifies the physical body as the 'beast of burden' whose function is to carry its precious passengers out of Egypt and on to the next stage of their journey.

THE MARRIAGE AT CANA[14]

The miracle Jesus performed at the marriage at Cana by transforming water into wine is 'the first of his signs'; it also symbolises something of the nature of the revelation he embodies for mankind. When the wine runs out at the marriage, Jesus instructs that the 'six stone jars ... for the Jewish rites of purification' be filled with water. When the

steward tastes the freshly drawn contents he discovers that the water has been turned to wine. He turns to the bridegroom and says, 'Every man serves the good wine first; and when men have drunk freely, then the poor wine; but you have kept the good wine until now.' If we recall that Moses struck water from the rock during the Israelites' journey through the wilderness, and that Jesus is the 'true vine' then we can begin to perceive something of the symbolic nature of the revelation. Stone, representing inanimate life, may also be regarded as standing for a literal or outer understanding of the truth. When broken open by Moses the rock poured forth the 'water' of the Old Covenant, the revelation to the Israelites and the higher understanding of the truth it brought with it. In being poured into the stone jars 'for the Jewish rites of purification' it represents the water of man's first baptism or physical birth. Jesus, by changing this water into wine reveals the nature of the New Covenant: man's baptism by water and the spirit, the fuller significance of which is revealed jointly at the Last Supper and the Crucifixion. It is already implied, however, in the steward's remarks to the bridegroom who, as often is the case in the New Testament, may be taken as a figure of Christ, '. . . But you have kept the good wine until now.'

The overturning of the Old Covenant symbolised in the Marriage extends into the episode immediately following, the Cleansing of the Temple, in which Jesus says, 'Destroy this temple, and in three days I will raise it up.' The Jews, representatives of the Old Order, understand him in a literal sense, implying their inability to comprehend the true nature of the New Covenant for in fact he is speaking of the temple of his body. In a more personal symbolic sense, the reader may understand these events to signify the completion of another stage in the spiritual transformation as the follower of Christ continues on his way to the Cross. Having been freed from the earlier bondage and dominion represented by Egypt and Herod, he is now being freed from the partial truth of his own 'old order' in preparation to receive the fuller revelation of the new.

THE WASHING OF THE DISCIPLES' FEET[15]

After the Ascension of Jesus it remains for his disciples to spread further the revelation he had brought to man. In this respect the washing of the disciples' feet may be regarded as a purification which forms part of their preparation for this work. It is a symbolic washing away of the first man, the 'man of dust'. A further and final stage in this preparation will take place at Pentecost when they receive the gift of the Spirit. (See Chapter 4, 'Ascent and Descent') As the verbal exchange between Jesus and Peter indicates, the disciples do not yet comprehend the fuller implications of Jesus' act, an understanding of which will come after the Crucifixion and Resurrection. In the personal context we have been examining, the washing of the feet may be understood as the washing away of man's earthly contact in preparation for the death he will symbolically share with Christ on the Cross.

THE CRUCIFIXION, RESURRECTION AND ASCENSION (1)

Many of the symbolic aspects of the Cross and Crucifixion have already been encountered elsewhere (Chapter 2, The symbolic 'Tree of Life'; Chapter 4, 'The Legend of the True Cross', etc.) but it is in their central place in the church building and liturgy that they continue to function as living symbols. In the establishment of the New Covenant the Crucifixion is the once-and-for-all living human sacrifice of the Son, the Lamb of God, which abolishes the animal sacrifice of the Passover lamb. Through becoming one with the 'Body of Christ' and by living a life 'in Christ', the Christian both participates in the sacrifice and shares in the sacrificial offering. The implications of this last point are such that they cannot be fully understood by what we call the rational mind, and yet to describe them as being 'purely symbolic' is to misunderstand the profundity of Christian symbolism.

A LITERAL OR SYMBOLIC TRUTH?

The difference between these two approaches or perceptions – the literal and the symbolic – is quite straightforward. It

is a matter of language – the language of knowledge. In the case of the rational mind its ability to comprehend a given thing depends, to a very large degree, on the knowledge concerning that thing that the mind already possesses. For example, it would be very difficult for someone to speak a language fluently without first having learnt something of that language's vocabulary and grammar. In this respect it is essentially knowledge as information; that is, it may be acquired through one form of learning process or another. In the case of symbols, however, a very different kind is involved; one which is frequently referred to as 'real' knowledge.

This 'real' knowledge is not acquired by learning in the same way that we learn information, because it cannot be learnt: it already exists in man, but on a very subtle, unconscious level. It is man's own innate or inner knowledge which, by its very nature, is at odds with knowledge as it is conceived in the rational mind. The latter, with its linear thinking processes, is only able to accept its own truth. That is to say, what it is able to assimilate and understand is perceived as being the truth and what it cannot assimilate cannot be the truth. This digestive process of learning means, at least, in as far as the rational mind is concerned, that the truth is envisaged to a large extent as lying outside of man. In this respect it can be described as a literal perception of the truth. On the other hand our innate knowledge, often referred to as our intuitive or sixth sense, provides us with a perception of the truth that appears to come from inside of man himself. This arrives at the mind having bypassed the latter's normal rationalising thought processes and, as such, appears in separation or opposition to the perception already established in the mind. The mind therefore finds itself faced with a choice at what is essentially an unconscious level and it responds by acting in one of two ways: it either opens up to this inner perception, thus assimilating it and making it its own, or it instinctively rejects it. In the first instance, where the mind acts as a meeting-point, this different and expanded perception may be described as symbolic. In the second instance, where we encounter the rejection, the mind retains its own original or literal perception. The one places a literal or historical event

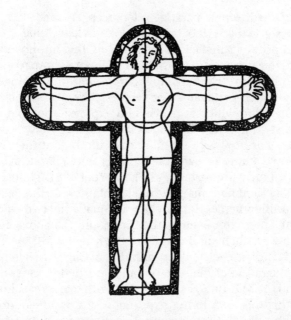

Figure 9. Man and the church, after Francesco di Giorgio

in its infinitely wider context; the other confines it within the limitations imposed on it by time and space. The one sees man arriving at a 'whole' view of what he perceives to be the truth, acknowledging it as such at both an inner and outer level and with his intuition and rational mind in agreement; the other, relying solely on the knowledge acceptable to the rational mind, is more in the nature of a half-truth.

The next thing is to consider where this 'inner' knowledge comes from. Does it come from man's own imagination? Or is it something that is given to him by the grace of God? The short answer is that it can be either or both and it is also therefore another instance where we have to be certain that we 'render to Caesar the things that are Caesar's, and to God the things that are God's'. There does come a point, however, where expressions such as 'inner' and 'outer', 'literal' and 'symbolic' serve only to confuse man. On the one hand there is a perception of an infinite unity, and on the other there is a tendency to define the reality of things by a process of

comparison through parallel references to 'this' and 'that'. In this sense even the term 'real knowledge' used earlier is not entirely satisfactory because of the implications of comparison it carries with it. And the more comparisons we make, the further we move away from that underlying sense of unity which permeates our very existence. The possibility of a perception which is in itself an expression of that unity, or at least compatible with it, is contained in these words of St. Paul, 'For now we see in a mirror dimly, but then face to face. Now I know in part; then shall I understand, even as I have been fully understood.'[16] The Gospel of St. Thomas, one of the Nag Hammädi manuscripts, contains a further example of this unified perception, 'When you make the two One, and you make the outer even as the inner, and the above even as the below . . . then shall you enter the Kingdom.'[17]

This brings us back to the profundity of Christian symbolism in its integration of the material and spiritual worlds. Byzantium and the Middle Ages have left us with their great churches and cathedrals as a living expression of this integration, an integration which in the twentieth century finds its principal expression in the living symbols of faith and the Christian life. In these the historical nature or actuality of the event of Jesus' life and its infinitely wider implications are both simultaneously present, as they are in the scriptures of the Holy Bible or in the rituals of the Church.

THE CRUCIFIXION, RESURRECTION AND ASCENSION (2)

It was stated earlier that through the Christian's being one with the body of Christ and by living a life 'in Christ' he also participates in the sacrifice of Christ on the Cross and shares in the sacrificial offering. In doing this he not only picks up his cross and follows Christ, he also denies himself by willingly sharing in the sacrifice on the Cross. In its wider implications this is the end of our own Adamic perception of the finality of death. Through losing our life we have found it, and when the fear of physical death is dispelled by the revelation of the empty tomb we are able to share fully in the joy of the Resurrection.

The words Jesus speaks to Mary Magdalene in the garden by the tomb, 'Do not hold [cling to] me, for I have not yet ascended to the Father,' may be taken as a further exhortation not to hold on to our former perception of things. For if we do, our own ability to ascend with Christ to the Father will remain at the level of a half-truth in our rational mind.

7 · EPILOGUE

'I am the door; if any one enters by me, he will be saved.'

It is in the unfoldment of the liturgical rituals within the church building itself that the varied and diverse elements of Christian symbolism come together to form a glorious unity in their celebration of the divine mysteries.

If we take into account the meeting of the macrocosm and microcosm referred to in earlier chapters as well as the subtle element of sacred geometry and add to them the idea of man's life on earth as a journey towards a unique goal, we may begin to see the church in terms of a three-dimensional symbol of man's spiritual journey which we ourselves undertake, at least in part, each time we make our way through the west door. In making this simple physical gesture we turn our backs on the material world to focus our physical and spiritual gaze on the altar at the east end and the light of the east windows which reminds us of the dawn of the new life that is the essence of the Christian revelation.

The beginning and end of this journey through the church take place at the opposite extremes of the nave, celebrated respectively in the two principal sacraments of the Church – Baptism and the Eucharist. The journey begins by the font in the west end where the Christian is initiated into a life in Christ through baptism by water and the spirit which, like all

Figure 10. Ground plan of Chartres Cathedral

the sacraments of the Church, is the outward sign of an inner grace. The second birth which takes place at this moment is a spiritual one and, through its re-enactment of the Baptism of Jesus by the water of John the Baptist and the descent of the Holy Spirit, it reminds us of the more profound implications of the Christian life; a life in which the Christian follows the life of Jesus through the annual cycle of religious festivals as well as in its celebration in the daily canon of church services and in his or her own private life as well.

The journey then takes us down the body of the nave, the symbolic Ship of Salvation, guiding us towards the crossing or chancel steps which is where we come into direct contact with the more profound mysteries of the Crucifixion and Resurrection. Ahead of us stands the altar, simultaneously the table of the Last Supper, the altar of the sacrifice and the tomb of the Resurrection. It is here that we witness the reliving of the redemptive act of the Death on the Cross, the central point of which is the consecration of the host and blood of the New Covenant. At the moment the host is raised up by the celebrant we are invited to participate on a profound level in a living sacrifice which is not only that of Christ but which is also, in as much as we are one with him, our own.

NOTES

1: SYMBOLISM AND CHRISTIANITY

1. Jacob Needleman, *Lost Christianity*, Element Books, 1990, p. 84.
2. Ira Progoff, 'Jung's Psychology and its Social Meaning', quoted in F.W. Dillistone, *Christianity and Symbolism*, SCM Press, London, 1985, p. 288.
3. F. W. Dillistone, op. cit., p. 296.
4. Mark 4:22.
5. Needleman, op. cit., p. 216.
6. 1 Corinthians 13:9–10.
7. Alan Watts, *Behold the Spirit*, Random House/Vintage Books, New York, 1972, p. 72.
8. Luke 10:38–42.
9. John 3:2–6.
10. Matthew 26:41.
11. John 3:12.
12. Colossians 1:15–16.
13. Romans 1:19–20.

2: THE ELEMENTS OF SYMBOLISM

1. Edward Robinson, *The Language of Mystery*, SCM Press, 1987, p. 101.
2. Richard Rolle, *The Fire of Love*, trans. Clifton Walters, Penguin Books, 1972, p. 78.
3. There are many images of God, the Divine Geometer. One is William Blake's frontispiece to *Europe, a Prophecy*. Another is a French thirteenth century miniature in the Osterreichische Nationalbibliotek, Vienna. (See figure 2).

4. A. C. Bridge, *Images of God*, Hodder and Stoughton, 1960, p. 114.
5. S. H. Hooke, *Middle Eastern Mythology*, Penguin Books, 1963, p. 11.
6. Ibid., p. 16.
7. Ibid., p. 165ff.
8. Stephen G. Nichols, Jr., *Romanesque Signs – Early Medieval Narrative and Iconography*, Yale University Press, 1983, p. 13.
9. Ibid., p. 10.
10. *A New Catechism*, Search Press, 1970, p. 33.
11. Alan W. Watts, *Myth and Ritual in Christianity*, Beacon Press, Boston, 1968, p. 207.
12. Revelation 21:1–4.
13. Exodus 2:10.
14. Mark 1:10.
15. Revelation 22:1.
16. John 4:14.

3: ASPECTS OF CHRISTIAN SYMBOLISM

1. The fifteenth century *Libro dell' Arte* opens with the words: 'Here begins the Craftsman's Handbook, made and composed by Cennino of Colle, in the reverence of God, and of the Virgin Mary, and of Saint Eustace, and of Saint John Baptist, and of Saint Anthony of Padua, and, in general, of all the Saints of God.' Cennino Cennini, *The Craftsman's Handbook* trans. Daniel V. Thompson, Jr., Dover Publications, New York, 1954, p. 1.
2. Ananda K. Coomaraswamy, *Christian and Oriental Philosophy of Art*, Dover Publications, New York, 1956, p. 41.
3. E. Panofsky, *Abbot Suger, on the Abbey Church of St. Denis*, Princeton, 1946. Quoted from E. Gilmore Holt, *A Documentary History of Art*, vol. 1, Doubleday Anchor, New York, 1957, p. 25. Suger's approach shared similar principles to those that governed Byzantine art. (See below, Chapter 3, The art of Byzantium).
4. Exodus 20:4.
5. Pierre du Bourguet S.J., *La Peinture Paléo-Chrétienne*, Editions Robert Laffont, Paris, 1965, p. 17f.
6. Ibid. pp. 22–23.
7. Steven Runciman, *Byzantine Style and Civilization*, Penguin Books, Harmondsworth, 1975, p. 9.
8. Quoted from Runciman, ibid. p. 81.
9. Ibid. p. 87. The first quotation is from John of Damascus; the second is from the author of the life of St. Stephen.
10. Ibid. p. 97.
11. Quoted from Stephen G. Nichols, Jr. op. cit. p. 16. The author also outlines the connection between the 'white garments' of the Transfiguration and the 'white cloak of churches.' p. 15.

12. Otto von Simson, *The Gothic Cathedral*, Princeton University Press, 1974, p. 37.

13. The 'Book of James', also known as the 'Protevangelium', was supposedly written by James, 'the brother of the Lord'. It was a valuable source for additional material related to the life of the Virgin Mary and the infancy of Christ. The popular medieval Bestiaries owed much to the earlier *Physiologus*. Their descriptions of the supposed characteristics of animals and fabulous beasts were moralistic in tone, providing the source for much animal symbolism (see Glossary: Eagle; Lion; Phoenix, etc.). The 'Golden Legend', compiled in the thirteenth century by Jacobus de Voragine, Archbishop of Genoa, includes material drawn from various earlier sources, as well as lives of the saints.

14. Quoted from O. von Simson, *The Gothic Cathedral*, p. 43.

15. Quoted from E. Gilmore Holt, *A Documentary History of Art*, vol. 1, p. 21.

16. Ibid. p. 21.

17. H. Kitto, *The Greeks*, Penguin Books, Harmondsworth, 1951, p. 190.

18. Ibid. p. 191.

19. C. Suarés, *The Cipher of Genesis*, Stuart & Watkins, London, 1970, p. 53.

20. T. Simcox Lea and F. Bligh Bond, *The Apostolic Gnosis*, Research into Lost Knowledge Organization, London, 1979.

21. Ibid. p. 17.

22. The Hebrew YHWH ('Yahweh'), known as the Tetragrammaton, reminds us that the Name of God was regarded as too sacred to pronounce. A 'name' in ancient times was more than a personal label; it denoted the essence of the person or deity. For example, Simon Bar-Jona is re-named by Jesus as 'Peter' (Aramaic: *Cephas*; Greek: *Petros*), signifying 'rock' (Matt. 16:17; John 1:42). God reveals His Name to Moses as 'I AM THAT I AM' or 'I AM' (Ex. 3:13–15). YHWH may also be taken to mean 'He causes to be' or 'He brings into existence whatever exists.' In later Judaism, with the acceptance of monotheism and belief in the one and only God, there was no need to identify the God of Israel with a proper name. The name Jesus used was 'Father' (Aramaic: *Abba*; see Matt. 14:36) and it is this name that expresses the Christian's own intimate relationship with God. (*A New Catechism* p. 115f).

23. Nigel Pennick, *The Ancient Science of Geomancy*, Thames & Hudson, London, 1979, p. 136f.

24. Wisdom of Solomon 11:20.

25. O. von Simson, op. cit., p. 11.

26. Ibid. p. 37.

27. In the present context it is not possible to give alchemy more than the briefest of mentions in its connection with Christian symbolism. Apart from the spiritual implications of 'the work' alchemists

(whether actually revealing themselves as such, or not) have made important material contributions to medicine and chemistry arising from their understanding of the nature of man and his relationship with the universe: 'It (alchemy) is from the outset a theory of how the world is related to human life . . . that the universe and the body are made of the same materials, or principles, or elements.' Dr. Jacob Bronowski, *The Ascent of Man*, BBC Books, London, 1990, p. 138. For an alchemic explanation of certain symbolic aspects of Notre-Dame, Paris, see *La Symbolique des Cathèdrales*, Ed. Fernand Schwarz, Homo Religiosus: Cahiers d'Etudes pour la Redècouverte du Sacre, Editions N.A., 1989, p. 29ff.

28. Titus Burckhardt, *Alchemy*, Element Books, Shaftesbury, 1986, p. 18.
29. Ibid. p. 189.
30. Ibid. p. 191.
31. Philippians 3:20–21.
32. *A New Catechism*, p. 220.
33. Emile Mâle, *The Gothic Image*, Collins/Fontana, London, 1961, pp. 390–1.

4: TYPOLOGY: THE OLD AND NEW TESTAMENTS

1. Bede Griffiths, *The Marriage of East and West*, Collins/Fount, London, 1983, p112.
2. Matthew 12:40.
3. Exodus 26:31–33.
4. Exodus 34:29–35.
5. Matthew 27:50–51.
6. Hebrews 9:11–12.
7. Hebrews 10:5–10.
8. Hebrews 10:19–20.
9. 2 Corinthians 3:14–16.
10. John 8:58.
11. John 1:1–17.
12. Jeremiah 31:31–34.
13. 1 Corinthians 15.
14. Luke 3:23–38.
15. The compilation of the legend given here is taken from J.C. Metford, *Dictionary of Christian Lore and Legend*, Thames & Hudson, London, 1983, p. 76; Roger Cook, *The Tree of Life*, Thames & Hudson, London, 1974, p. 122; and other sources.
16. Genesis 11:1–9.
17. For example see Maurice Nicoll, *The New Man*, Shambhala Publications, Boulder, 1981, pp. 10–11.
18. Acts 2:4–6.
19. Genesis 17:1–18:14.

20. Genesis 25:21–34.
21. Genesis 28:10–22.
22. Genesis 29:1–10.
23. For the Israelite's journey, see Numbers 33; for Christ's genealogy, see Matthew 1:17; for Origen, see 'Homily XXVII on Numbers', *The Classics of Western Spirituality: Origen*, Paulist Press, New York, 1979. The translation of the place names given to the 42 stages of the Israelite's journey, and their interpretation provide an extra insight into the nature of the journey of the soul.

5: THE LIFE OF CHRIST (1)

1. John 8:23.
2. Matthew 13:1–18; Mark 4:1–29; Luke 8:4–15.
3. Luke 15:11–32.
4. Luke 4:14–24.
5. Mark 5:1–20; also see Luke 8:26–39.
6. Romans 10:17.
7. James 1:7–8.
8. 2 Corinthians 1:17–20.
9. *A New Catechism*, p. 291.
10. James 2:17.
11. Matthew 6:10.
12. Luke 22:42.
13. Matthew 16:15–23; Mark 8:27–33.
14. John 13:5–15.
15. John 13:36–38.
16. Mark 8:34–38.
17. Mark 35–36.
18. Mark 14:72.
19. John 21:7–17.

6: THE LIFE OF CHRIST (2)

1. John 1:1–14.
2. Luke 20:25.
3. John 14:20.
4. Matthew 16:24–25.
5. Galatians 2:20.
6. 1 Corinthians 9:22.
7. John 1:23.
8. John 3:27.
9. John 3:31.
10. John 3:30.
11. For a full introduction to the Virgin Mary, see Marina Warner, *Alone*

of All Her Sex – The Myth and Cult of the Virgin Mary Pan Books, London, 1983.
12. Luke 3:9.
13. Luke 1:38.
14. John 2:1–11. For a further explanation, see Maurice Nicoll, op. cit. pp. 28–37.
15. John 13:1–20.
16. 1 Corinthians 13:12.
17. The Gospel of St. Thomas, presented by Hugh McGregor Ross, Distributed by Element Books, Shaftesbury, 1987, p. 24.

GLOSSARY OF SYMBOLS

This Glossary of Symbols may be used in conjunction with the main text of the book or for independent reference. The entries vary in length: some of the longer ones expand points which could not be made effectively elsewhere, some are relatively short summaries of material contained in the preceding chapters while others, usually connected with Christian iconography, are very brief. Individual entries should not to be regarded as either definitive or conclusive and the reader should feel free to interpret them further, or work with them in whichever way he or she feels appropriate. Biblical quotations and references, as well as a number of cross-references, have been included to help broaden the scope of each entry.

Adam: (Hebrew *adama*, meaning 'earth'.) Adam represents the primordial or first, physical state of man. 'The first man was from the earth, a man of dust; the second man is from heaven . . . Just as we have borne the image of the man of dust, we shall also bear the image of the man of heaven.' (1 Cor.

15:47–49). The Greek letters of Adam's name give the initial letters of the Greek names for the four directions or points of the compass: *Anatole, Dsysis, Arctos, Mesembria.* He can thus be seen as representing the physical world, as well as mankind and individual man. (See Apple; Breath; Fall; Man; and also Chapter 4, The Second Adam.).

Alpha and Omega: 'Alpha' and 'Omega' are the first and last letters of the Greek alphabet. 'I am the Alpha and the Omega,'

Figure 11. Alpha and Omega

says the Lord God, who is and who was and who is to come, the Almighty.' (Rev. 1:8). These words are repeated by Christ towards the end of the Apocalyptic vision: 'I am the Alpha and the Omega, the first and the last, the beginning and the end.' (Rev. 22:13). All things, whether they are perceived as being fixed in time, or space, or as being beyond these dimensions, have their origin and conclusion in God. Their true nature is revealed to man through the union of the Son, the living and ascended Christ, with the Father.

Anchor: 'We have this as a sure and steadfast anchor of the soul, a hope that enters into the inner shrine behind the curtain, where Jesus has gone as a forerunner on our behalf . . .' (Heb. 6:19). The anchor signifies man's hope and salvation, the 'safe haven' he finds in Christ. The anchor and dolphin combined represent Christ on the Cross. (See Dolphin; Fish).

Animals: Symbolic animals are generally represented natu-

ralistically or as fabulous beasts. The latter tend to signify the powerful forces present in the unformed world. Groups of animals recall numerical symbolism, e.g. twelve sheep represent the twelve disciples. (See entries under individual

Figure 12. Fabulous beast, from S. Ambrogio,
Milan, 13th century

animals: Ass; Dragon; Lamb; etc.) In a more general sense animals represent man's lower or animal nature, i.e. his temporal estate. 'We all make many mistakes, and if any one makes no mistakes in what he says he is a perfect man, able to bridle the whole body also. If we put bits into the mouths of horses ... we guide their whole bodies.' (James 3:2–3).

Apple: The Forbidden Fruit of the Tree of the Knowledge of Good and Evil and, as such, the Fruit of the Fall. It is against God's Will for man to eat this Fruit, but he is tempted into eating it all the same. Eating the Fruit is to serve 'the creature rather than the Creator' (Rom. 1:25), thereby precipitating the Fall from Paradise in which man lives in harmony with his fellow creatures and with God. It also represents the temptation or attraction of the material world which perpetuates man's apparent separation from God and further diverts him from playing his part in fulfilling the divine purpose. (See Fall; Tree.)

Ass: Patience and humility. The beast of burden that carried the unborn Christ to his birthplace, the newly-born Christ into and out of Egypt, and which the adult Christ rode on

entering Jerusalem. It stands for our lower or animal nature or, alternatively, the physical body (referred to by St Francis of Assissi as 'poor brother donkey'). Its normally stubborn nature is sometimes used to parody those who refuse to believe, as in the story of Balaam's Ass. 'Then the Lord opened the mouth of the ass, and she said to Balaam . . . "Am I not your ass, upon which you have ridden all your life long to this day?"' (Num. 22:21–35 and 2 Peter 2:15–17).

Babylon: Likened to the city of Rome, but also the antithesis of the Heavenly City. 'Babylon the great, mother of harlots and of earth's abominations' (Rev. 17:5). 'So shall Babylon the great city be thrown down with violence . . .' (Rev. 18:21). The 'Great Whore of Babylon' and the 'great city' stand for the deceptive temptations of the material or physical aspect of God's Creation. 'How the faithful city has become a harlot.' (Isaiah 1:21) (See City; Garden).

Bee: Bees were thought to reproduce by parthenogenesis (Greek *parthenos* meaning 'virgin'), retaining their virginity, and therefore they symbolise the Incarnation and Virgin Birth. Through their industry they produce honey, one of the foods of the Promised Land. (See Honey; Promised Land.)

Beehive: The Virgin Mary in her own right, and also as the figure of the Church or Christian community. The members of the latter, like the bees in the hive, are united by their industry and common purpose into one body, the Body of Christ.

Bird: The transcendent soul or spirit. In Ancient Egypt, a bird with a human head signifies the soul which flies from the body after death. Such a bird frequently appears in the art of the Middle Ages, particularly in sculpture. In medieval iconography it is often shown enmeshed in foliage. This can be interpreted as representing the binding of man's soul in the physical world, from which it seeks to be released.

Figure 13. Enmeshed birds

Blood: Blood signifies sacrifice and also the physical life-force which, transformed into wine by the sacrifice of Christ's Crucifixion, becomes the spiritual life-force, 'For . . . my blood is drink indeed.' (John 6:55). (See Chalice; Water; Wine).

Book: The Word of God. It also represents authoritative learning or wisdom. In Christian iconography an open book often reveals a relevant prophecy or saying.

Brazen serpent: 'And the Lord said to Moses, "Make a fiery serpent, and set it on a pole; and every one who is bitten, when

Figure 14.
Brazen serpent

he sees it, shall live."' (Numbers 21:8). Moses' 'brazen serpent', with its power of healing, is, in the words of Christ, a type of the Crucifixion and Redemption: 'And as Moses lifted up the serpent in the wilderness, so must the Son of man be lifted

up, that whoever believes in him may have eternal life.' (John 3:14–15). (See Rod; Serpent.)

Bread: Bread, like wine, is produced by a process which transforms the original ingredients, signifying the transformation of man from his raw, physical state into a spiritualised being. The process entails the blending of the separate ingredients, the addition of yeast, kneading, proving, shaping into loaves, and baking in an oven. Bread has the dual symbolism of material and spiritual food: 'It is written, "Man shall not live by bread alone . . ."' (Matt. 4:4); 'Jesus said to them, "I am the bread of life . . ."' (John 6:35). The Body of Christ, broken and shared in the Eucharist, is the source of man's Redemption. In sharing the Eucharistic bread, the communicants become one in, and with, the Body of Christ. 'The bread which we break, is it not a participation in the body of Christ? Because there is one bread, we who are many are one body, for we all partake of the one bread.' (1 Cor. 10:16–17). (See Leaven; Oven.)

Breath: Synonymous with spirit (Latin *spiritus*=spirit or breath). 'Then the Lord God formed man of dust from the ground, and breathed into his nostrils the breath of life; and man became a living being.' (Gen. 2:7). Breath represents the life-giving or generative power of the Spirit.

Butterfly: Because of its life-cycle in which it emerges from a chrysalis, and subsequently takes flight, it symbolises the Resurrection.

Candle: The Divine Light illuminating the darkness of the world. Christ as the Light of the World. The two candles on the altar can be seen to represent the dual nature (human and divine) of Christ which are united in the cross that stands between them. (See Cross; Lamp; Light.)

Chalice: The cup from which wine, the 'Blood of Christ', was drunk at the Last Supper. The chalice is also depicted

collecting the blood which flowed the wound in Christ's side

Figure 15.
*Chalice. English,
14th century*

at the Crucifixion – a symbol of the Eucharist and the Redemption of man. In addition it symbolises the heart yearning to be filled with wine from the True Vine. (See Blood; Grail; Heart; Vine; Wine.)

City: The city is both the dwelling place of man and a microcosm. There are two contrasting cities, Babylon and the Heavenly City. The one is founded on earth and is overthrown on the Last Day (Rev. 18). The other, founded in heaven, is 'the city of the living God', revealed as the new dwelling of God with man (Rev. 21–22:5). (See Babylon; Garden.)

Cock: A symbol of vigilance and watchfulness often represented on the weather-vane on top of a church spire. 'Watch therefore – for you do not know when the master of the house will come, in the evening, or at midnight, or at cockcrow, or in the morning – lest he come suddenly and find you asleep.' (Mark 13:35–36). 'And Peter remembered the saying of Jesus, "Before the cock crows, you will deny me three times."' (Matt. 26:75). It awakens the sleeping world and, as the bird that signals daybreak and the rising of the sun, it also announces the new dawn of the Light of the World.

Columbine: 'Dovelike', therefore a symbol of the Holy Spirit.

Cow: A symbol of fertility and plenty. The cow provides milk,

one of the foods of the Promised Land. (See Milk; Promised Land.)

Crescent moon: A symbol of the Virgin Mary as Queen of Heaven.

Crook/crozier: Symbol of the authority of a bishop as shepherd of his flock, recalling Christ, the Good Shepherd. (See Shepherd.)

Cross: The Crucifixion. The salvation/redemption of mankind through the Death and Resurrection of Christ. For man, death on the cross represents the 'death' of his old self in order to find a new life, 'If any man would come after me, let him deny himself and take up his cross and follow me. For . . . whoever loses his life for my sake will find it.' (Matt. 16:24–25). The Legend of the True Cross associates the Tree of the Fall with the Cross of the Crucifixion. In wider symbolic terms the figure of the cross (the conjunction of horizontal and vertical) represents duality and the union of opposites. In this sense the cross is common to other traditions and shares much of the symbolism of the Tree. (See Fall; Tree; also Chapter 2, The symbolic 'Tree of Life', and Chapter 4, The Legend of the True Cross.)

Darkness: The primordial, unformed darkness before God sent His Light into the world, 'The earth was without form and void, and darkness was upon the face of the deep.' (Gen. 1:2). As such, darkness is the realm of the 'dark forces' of evil and the Devil, the Prince of Darkness. It also signifies spiritual darkness or blindness, the darkness which precedes the coming of light. 'In him was life; and the life was the light of men. And the light shineth in darkness; and the darkness comprehended it not.' (John 1:4–5). (See Light.)

Desert: The barrenness of the desert, caused by the fiery heat of the sun, suggests a withdrawal from the 'city' (see Babylon)

and the attractions of the material world to a place of quiet, spiritual contemplation. The desert also signifies desolation and abandonment.

Figure 16. *Oil lamp in the shape of a dolphin.*
Coptic, 8th century

Dolphin: The dolphin, through its reputation of saving sailors from the waters, signifies salvation through Christ. (See Anchor; Fish.)

Donor: In Christian art donors are frequently depicted in the works they commissioned – kneeling in prayer, offering a church, etc. Although in themselves they might not appear to be symbols, they form a symbolic link between material and spiritual reality. This link may be interpreted in many ways, for example, the material world leading us towards the spiritual world, etc.

Door: A symbol of the entrance to the Kingdom of Heaven, and of Christ. 'I am the door; if any one enters by me, he will be saved . . .' (John 10:9). In more general terms, the door is an entrance signifying an opening into a new life, or the passage from one world to another, hence the elaborate decoration around church doorways. (See Gate; Key.)

Dove: 'And John bore witness, "I saw the Spirit descend as a dove from heaven . . ."' (John 1:32). The presence of the Holy Spirit, especially in scenes of the Incarnation or Annunciation, the Baptism of Christ, and Pentecost, is represented by a

symbolic dove. The dove which brings the olive leaf to Noah after the Flood symbolises the deliverance and peace that comes with the reconciliation between man and God.

Dragon: A fabulous animal representing man's primordial enemy: the 'dark forces' of the nether worlds, or evil, as personified in Satan, 'And the great dragon . . . that ancient serpent, who is called the Devil and Satan, the deceiver of the whole world . . .' (Rev. 12:9). The winged dragon combines the symbolism of the serpent and the bird (matter and spirit), the one imprisoning the other. 'Killing the dragon' releases man from the forces that ensnare his soul or spirit. (See Bird; Serpent).

Eagle: The king of birds; a symbol of the Ascension, and of Christ. The eagle was reputed to be able to look directly into the sun, without diverting its gaze. It trained its young to do likewise, rejecting those who failed. In this respect it represents Christ who raises his followers, through faith, to contemplate God, the Source of Divine Light. Those who lack sufficient faith fall back into the world. Because of its keen eyesight the eagle is able to see a fish in the sea and dive down to pluck it out of the water. Similarly Christ draws man out of the chaos of the deep (See Fish; Water). The eagle holding a serpent in its talons or beak represents the triumph of Christ over the 'dark forces' of the world. (See Serpent). It is also the symbolic attribute of St John the Evangelist.

Easter egg, RABBIT: The rebirth or renewal of life.

Egype: Egypt signifies the material world or man's lower nature and the imprisonment of his soul within the body. 'Then the Lord said, "I have seen the affliction of my people who are in Egypt . . . I know their sufferings, and I have come down to deliver them out of the hand of the Egyptians, and to

bring them up out of that land to a good and broad land, a land flowing with milk and honey.'" (Ex. 3:7–8). Through the Grace of God, man is released from this bondage and led towards the Promised Land. (See Promised Land).

Eye: The eye represents physical and spiritual sight, the eyes being the 'window of the soul' through which the Divine Light enters the body. 'The light of the eyes rejoices the heart.' (Prov. 16:30). 'The eye is the lamp of the body. So, if your eye is sound, your whole body will be full of light; but if your eye is not sound, your whole body will be full of darkness.' (Matt.6:22–23). To see with one eye is to see the unity of life rather than its apparent duality, 'If your eye causes you to sin, pluck it out and throw it away; it is better for you to enter life with one eye than with two eyes to be thrown into the hell of fire.' (Matt. 18:9). (See Light; Window).

Fall: The Fall or Expulsion from Paradise represents man's apparent separation from God, his Creator. Man, relying on his own dualistic vision of the world, sees things in separation, as existing independently of each other – matter and Spirit, body and soul, man and God. Through God's Love man becomes aware of his origin in God and is given the opportunity to overcome the bonds of this apparent duality and return to Paradise. (See Adam; Apple; Paradise).

Fire: Fire is an ambivalent symbol representing both destruction and regeneration: the 'flames of Hell' or the 'tongues of fire' of the Holy Spirit. It can also denote the Resurrection (see Phoenix), and the process of transformation (see Bread; Oven) by which man becomes a spiritualised being.

Fish: In general terms the symbolism of the fish is very closely linked to that of water, signifying the presence of the life-force in the chaotic, primordial waters, or the Christian

soul swimming in the waters of life (see Eagle; Water). Its use in Christianity originates from very early Christian times – *Icthus*, the Greek word for 'fish', gives the initial letters of the acrostic *Iesous CHristos, THeou Uios, Soter* (Jesus Christ, Son of God, Saviour). At the feeding of the four and five thousand, the crowd are fed with fish and bread, symbolising the material and spiritual food offered by Christ. At the calling of the disciples, Jesus says that he will make them 'fishers of men' (Matt. 4:19); possibly as a result of this the faithful were called *pisciculi* (little fish) by the early Church Fathers. In this sense 'fishing' can signify the spiritual awakening or rebirth that comes about with the soul's emergence from the murky waters of the deep, through the sacrament of Baptism, into a new life. In the Book of Tobit, the archangel Raphael explains the magical properties of a man-eating fish to Tobias (Tobit 6). The fish's gall restores the sight of Tobit, his father (Tobit 11). The *vesica piscis* (Latin, 'fish-bladder') is a geometric figure, also called a mandorla, which frequently surrounds the figures of Christ or the Virgin and Child. (See *Vesica piscis*).

Fleur de lis: A stylised lily (see Lily). Its three prongs also signify the Holy Trinity.

Flowers: The flower is simultaneously the cause and effect, the culmination and beginning, the 'begotten' of the plant and 'begetter' of the seed from which the plant grows. Its form, the calyx (Latin *calix*=cup), links it physically and etymologically with the chalice. It is frequently a symbol of the Virgin Mary. (See Chalice; Lily; Rose).

Foot: Our point of contact with the material world or earth and, as such, a symbol of our lower or earthly nature. To go barefooted is a sign of poverty or humility. It is also a casting-off or renunciation of earthly things and our literal interpretation of them, '. . . put off your shoes from your feet, for the place on which you are standing is holy ground.' (Ex. 3:5; Josh. 5:15). (See Shoes).

Fountain: Unlike the dark and chaotic waters of the deep, those of the fountain are the source of life, 'a well of living water' (Song 4:15), the living waters of redemption and purification. 'A fountain sealed' (Song 4:12) is a type for the Virgin Mary, from whom the spritual water of salvation (i.e. the wine of Christ) will flow. (See Water).

Fruit: As the Fruit of the Fall it symbolises worldly attraction (see Apple). The Redemption of man comes through Christ, the Second Adam, source of 'the fruits of righteousness' (Phil. 1:11). Christ is also referred to as the 'First Fruit of the Virgin'. (See Fall, Tree).

Garden: The Garden of Eden is where, prior to the Fall, man dwelt in harmonious union with God and His Creation. It is the original paradisic state from which man goes out into the world. God holds out to man the promise of a new paradise. This is the Promised Land to which man seeks to return after his wandering in the wilderness, or the Heavenly City which is revealed to man at the fall of 'Babylon', the earthly city. (See Babylon; City; Fall; Paradise; Promised Land; Wilderness). The enclosed or locked garden is a type of the Virgin Mary (Song 4:12). St Antonine encourages us 'to cultivate the little garden of the soul' so that the Christ within us may be born. A garden is also the significant setting for Christ's Agony, Entombment and Resurrection.

Garments: Symbol of concealment and/or protection. 'And the Lord God made for Adam and for his wife garments of skins, and clothed them.' (Gen.3:21). 'Thou didst cover it [the earth] with the deep as with a garment.' (Psalm 104:6). (See Woven Fabric). The nature of the outer garments may reflect the inner nature of the person wearing them, 'For life is more than food, and the body more than clothing.' (Luke 12:23). 'And the angel said to those who stood before him, "Remove the filthy garments from him." And to him he said, "Behold, I

have taken your iniquity away from you, and I will clothe you with rich apparel.'" (Zec. 3:4). It also represents what needs to be left behind in order to enter the new life, 'Let him who is in the field not turn back to take his mantle.' (Mark 13:16). The parable of the patched garment illustrates that Jesus' message cannot be compromised or adapted to fit into old beliefs: 'No one tears a piece from a new garment and puts it upon an old garment; if he does, he will tear the new, and the piece from the new will not match the old.' (Luke 5:36)

Gate: The gate or gateway shares in the symbolism of the Door – as Christ is the 'door', the Virgin Mary is the 'gate of heaven'. She is also the *porta clausa*, 'the outer gate of the sanctuary, which faces east; and it was shut . . . for the Lord, the God of Israel, has entered by it; therefore it shall remain shut. Only the prince [Christ] may sit in it to eat bread before the Lord . . .' (Ezekiel 44:1–3). The gate indicates the entrance to a new life or level which is traversed in humility or spiritual poverty, 'Enter by the narrow (strait) gate; . . . for the gate is narrow and the way is hard that leads to life . . .' (Matt. 7:13). (See Door).

Globe: A globe surmounted by a cross signifies Christ's rule over the world as its Saviour.

Gold: An ambiguous symbol as it represents both outer material wealth and inner spiritual treasure. Idolatry arises from the confusion or corruption of one with the other e.g. Aaron and the Golden Calf, (Ex. 32:1–8). The alchemic process of turning base metals into gold symbolises the work of transmuting all that is base in man into the pure gold of the spirit. (See Chapter 3, 'Alchemy').

Goldfinch: It frequents thorns and thistles and in Christian art symbolises the suffering of Christ's Passion. (See Thistle/Thorn).

Grail: The Holy Grail is, according to legend, either the dish on which the Paschal Lamb was served at the Last Supper or the cup or chalice with which Christ instigated the Eucharist.

Joseph of Arimathea collected in it Christ's blood shed on the Cross. It is the central object of the medieval 'Quest of the Holy Grail' which combines both Christian and Celtic symbolism in the mythical saga of man's search for the Grace of God and eternal life.

Grapes: Interchangeable with the symbolism of vine and wine. Through the wine-making process (harvesting, crushing and fermentation), grapes are transformed into wine, symbolising man's spiritual transformation. (See Vine; Wine).

Figure 17. Grapes. Coptic, 4th century

Guardians: In pagan legends a hidden treasure, or the gateway to another realm, is often protected from intruders by supernatural animals or beings. These 'guardians' can usually only be overcome by a hero in mortal combat. This either

Figure 18. Guardian. St. Gilles, France, 12th century

incurs the death of the hero or else he enters on a new phase of his adventurous journey. Such guardians are frequently found

placed amongst the decorative sculpture around a church doorway.

Halo: A circle, generally portrayed by golden light, which signifies the divinity or sanctity of a person. Christ's halo usually incorporates the Cross.

Hand: In Christian art the 'Hand of God' is frequently depicted emerging from a cloud; it symbolises His divine presence.

Hart: A symbol of the Christian soul yearning to be reunited with God. 'As a hart longs for flowing streams, so longs my soul for thee, O God.' (Psalm 42:1).

Heart: As the heart is the organ that circulates man's life-blood it signifies the physical and spiritual centre of man. Man is what is in his heart, 'Do not lay up for yourselves treasures on earth . . . but lay up for yourselves treasures in heaven . . . For where your treasure is, there will your heart be also.' (Matt. 6:19–21; also Luke 6:45). A heart pierced with three nails and encircled by the Crown of Thorns is the 'Sacred Heart of Jesus'. A heart pierced by a sword and encircled by a wreath of roses is the Heart of the Virgin Mary.

Iris: The shape of its leaf gives it the name 'sword lily'. In Christian art it is, like the lily, a symbol for the Virgin Mary.

Key: A key is the means to open a lock or door, giving access to whatever lies bound behind the door. Jesus says, 'Woe to you lawyers! [the literalists] for you have taken away the key

of knowledge.' (Luke 11:52) It is an attribute of the apostle Peter. Following Peter's recognition of Jesus as 'the Christ', Jesus says to him, 'I will give you the keys of the kingdom of heaven, and whatever you bind on earth shall be bound in heaven, and whatever you loose on earth shall be loosed in heaven.' (Matt. 16:15–20). (See Door; and Chapter 5, 'Peter').

King: God is 'the King of kings'. The king is the supreme ruler over his kingdom and is a symbol of spiritual and/or temporal lordship.

Labyrinth: Labyrinths and mazes symbolise the bondage or entanglement of man's soul in the material world and/or the tortuous journey that faces man in his endeavour to free himself from this in order to reach his spiritual centre or the Heavenly City. They were also regarded as symbolic subsitutes for pilgrimage. (See Pilgrimage).

Ladder: A link symbolising the point of communication between heaven and earth, as seen by Jacob in his dream, 'And he dreamed that there was a ladder set up on the earth, and the top of it reached to heaven; and behold, the angels of God were ascending and descending on it!' (Gen. 28:12). In the Middle Ages it was considered as a type for the Virgin Mary who, through the Incarnation, brought about the union of heaven and earth, the divine and the human.

Lamb: Symbol of Christ, 'Behold, the Lamb of God.' (John 1:36). The Jewish Passover lamb commemorated the Lord's deliverance of the Israelites out of Egypt; their salvation was guaranteed by the blood of a lamb painted on their doorways (Ex. 12:1–13). The salvation of all men is made possible through the blood shed in the sacrifice of Christ, the new Paschal Lamb, on the Cross. The Lamb is therefore a symbol of the resurrected and living Christ, '. . . the Lamb who was

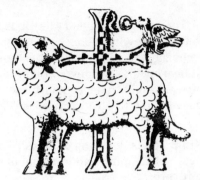

Figure 19. Lamb with Cross and Dove. Italian, 6th century Italian crozier

slain ...' (Rev. 5:12). The early Christian image of Christ carrying a lamb represents the Good Shepherd caring for his flock.

Lamp: The Divine Light. Wisdom or knowledge. 'The eye is the lamp of the body' (Matt. 6:22). (See Eye, Light). It is also a symbol of Christ, 'And the city has no need of sun or moon to shine upon it, for the glory of God is its light, and its lamp is the Lamb.' (Rev. 21:23).

Leaven: A multiple symbol. Leaven is yeast which, secretively, permeates the whole lump of dough. It can symbolise the workings of corruptive forces as when Jesus, the true Bread of Life, warns his disciples 'Beware of the leaven of the Pharisees, which is hypocrisy.' (Luke 12:1). The ability of leaven to inflate or 'puff up' is pointed out by St Paul, 'Your boasting is not good. Do you not know that a little leaven leavens the whole lump? Cleanse out the old leaven that you may be a new lump, as you really are unleavened. For Christ, our paschal lamb has been sacrificed. Let us, therefore, celebrate the festival, not with the old leaven, the leaven of malice and evil, but with the unleavened bread of sincerity and truth.' (1 Cor. 5:6–8; see also 1 Cor. 8:1–3). Unleavened bread symbolises the state of purity necessary in order to leave the old life behind and emerge into a new life, e.g. the Israelites ate unleavened bread for seven days in their preparations for

their exodus from Egypt, (Ex. 12:14–20; Deut. 16:1–4) (see also Egypt). Unleavened dough is able to receive fresh yeast (the Holy Spirit), 'The kingdom of heaven is like leaven which a woman took and hid in three measures of flour, till it was all leavened.' (Matt 13:33). (See Bread).

Light: The enlightening power of the Divine Light which penetrates the 'darkness of unknowing'. Light, in itself form-less, gives form, and consequently meaning, to that which emerges from the dark, formless void (Gen. 1:1–2). Man seeks 'illumination' in his own lifetime, and it is Christ, 'the Light of the World', who brings a new meaning and understanding of the world and this life to man. In the words of St Paul, '. . . the Lord comes, who will bring to light the things now hidden in darkness and will disclose the purposes of the heart.' (1 Cor. 4:5). This new and future understanding, like the light it emanates from, is beyond the comprehension of the rational mind because it emanates from the heart of things. 'I shall light in your heart the lamp of understanding, which shall not be put out . . .' (2 Esdras 14:25). A bright star from the east, shining in the darkness of the night, heralds the birth of Christ, for whom the Virgin Mary is the 'Light-bearer'. (See Darkness; Eye; Lamp).

Lily: The white Madonna lily, as its name implies, is a symbol of the Virgin Mary or, equally, the state of purity and chastity attributed to her. A virgin or uncorrupted state is a necessary pre-requisite for the Incarnation of the Word, but it can also be seen as signifying the purified soul, freed from corruption by the material world. In Christian art it is depicted in scenes of the Annunciation, often in the hand of the Archangel Gabriel, God's heavenly messenger.

Lion: A symbol of the Resurrection because, according to legend, the lion's cubs are born dead and are brought to life by the lion breathing life into them. The lion also signifies Christ, the Messianic king, '. . . the Lion of the tribe of Judah, the Root of David, has conquered, so that he can open the scroll and its

seven seals.' (Rev. 5:5; also Gen. 49:9–10). It is the symbolic attribute of St Mark.

Magi: The 'Three Wise Men' or 'Three Kings' signify man's total or three-fold submission (on the levels of body, mind, spirit) to the Infant Christ. The Adoration of the Kings represents Christ's manifestation or Epiphany to the Gentiles, that is, to all of mankind.

Man: 'So God created man in his own image, in the image of God he created him; male and female he created them.' (Gen. 1:27). The symbolism of 'man' is multiple and complex. For example, it can be seen to represent the human race or mankind as a whole, or the individual person (whether male or female). The term 'son of man' can be taken as signifying the individual human being while the 'Son of man', Jesus Christ, can be seen as the whole and perfect man. A winged man is the symbolic attribute of St Matthew.

Mandorla: Also known as the *vesica piscis*. It is the almond-like shape that frequently surrounds Christ or the Virgin Mary in medieval iconography. It is a figure from sacred geometry formed by the intersection of two circles. (See *Vesica Piscis*)

Manna: The miraculous food or 'bread from heaven', symbolising the Grace of God, which appeared each morning, six days a week, to feed the Israelites during their wanderings after their deliverance out of Egypt. One explanation for the name is that it derives from the Hebrew *man hu* meaning 'what is it?'. 'When the people of Israel saw it they said to one another, "What is it?" For they did not know what it was. And Moses said . . . "It is the bread which the Lord has given you to eat."' (Exodus 16:15). Jesus says, 'I am the living bread which came down from heaven.' (John 6:51). The Body of Christ is the new spiritual food for all men. (See Bread).

Marriage: Marriage, manifested on one level in the union of man and woman, symbolises the union of opposites. Out of the union of such opposites a new birth or life is made possible. On another level it symbolises the union of the human and divine, the material and the spiritual, heaven and earth. The symbolism of bridegroom and bride, lover and Beloved, often refers to the relationship between God and man, or Christ and the Church. (See Rev. 21:9–10).

Maze: See Labyrinth.

Milk: One of the foods of the Promised Land. Milk is the food of the newly-born, 'Like newborn babes, long for the spiritual milk, that by it you may grow up to salvation.' (1 Peter 2:2).✓

Mill/millstone: The mill and millstone play an active role in the process which transforms corn to bread (see Bread). Like the winepress, the millstone may be seen to represent the wrath of God.

Mirror: The reflection seen in the mirror is only a reflected image, a vague reflection of reality as it really is, 'For now we see in a mirror dimly, but then face to face' (1 Cor. 13:12). A polished or spotless mirror reflects a true image. The figure of Wisdom is likened to the 'spotless mirror', 'For she is a reflection of eternal light, a spotless mirror of the working of God, and an image of his goodness.' (Wisdom 7:26). The spotless mirror is a symbol of the Virgin Mary. The clear or polished mirror is also a universal symbol of the heart or soul.

Moon: The feminine, receptive principle, in contrast to the sun which is the masculine, active principle. The moon is a symbol of the Virgin Mary whereas the sun is a symbol of Christ. The moon and sun depicted together represent

103

simultaneously duality and the union of opposites. With the coming of the Heavenly City their symbolic light is no longer needed, 'And the city has no need of sun or moon to shine upon it, for the glory of God is its light.' (Rev. 21:23).

Mountain: There are many references to mountains and high places in both the Old and New Testaments. As a point on the earth which reaches heavenwards it symbolises the mystical communication between heaven and earth: both the giving of the Tablets to Moses and the Transfiguration of Christ take place on high mountains. As an extension of this symbolism a high place or level, whether inner or outer, signifies spiritual elevation away from worldly things.

Net: An ambivalent symbol representing both the binding snares of the world and the net of salvation. 'For in vain is a net spread in the sight of any bird; but these men lie in wait for their own blood, they set an ambush for their own lives.' (Prov. 1:17–18). '"Follow me, and I will make you fishers of men." And immediately they left their nets and followed him.' (Matt.4:19–20). 'The kingdom of heaven is like a net which was thrown into the sea and gathered fish of every kind.' (Matt. 13:47). (See Fish; Veil; Woven Fabric).

Oil: The anointing with oil signifies a consecration or dedication to God, thereby bestowing grace and rendering the anointed person or object holy. After Jacob's dream (see Ladder, and Gen. 28:10–17), he takes the stone on which he had rested his head 'and set it up for a pillar and poured oil on the top of it. He called the name of that place Bethel [The House of God].' The Old Testament kings were 'the Lord's anointed.' The awaited king and promised deliverer of the Jews, a descendant of David to be born in Bethlehem, was 'the Anointed One' (Hebrew: *Messiah*; Greek: *Christos*). In

the Parable of the Wise and Foolish Virgins, the Five Foolish Virgins were away buying oil when the bridegroom (Christ) arrived for the marriage feast (Matt. 25:1–13). Oil was also used for healing, as in the Parable of the Good Samaritan, 'But a Samaritan . . . went up to him and bound up his wounds, pouring on oil and wine.' (Luke 10:30–37). The oil used is generally olive oil.

Olive tree: The olive branch is a symbol of peace. The dove returns to Noah with 'in her mouth a freshly plucked olive leaf,' (Gen. 8:12). It heralds the end of the Flood and the coming peace of God's covenant with Noah. In scenes of the Annunciation the Archangel Gabriel sometimes carries an olive branch to announce the coming of Christ, the Prince of Peace, through whom a new covenant is made between God and man.

Oven/furnace: The fires of transformation (see Bread). The alchemist's symbolic oven, the crucible or athanor, in which the work of transmutation takes place, corresponds to the human body.

Ox: Symbol of suffering, patience, and sacrifice. It is the symbolic attribute of St Luke.

Palm: A symbol of martyrdom, victory over death, and Christ's entry into Jesuralem.

Paradise: Paradise is the state in which man lives in harmony with God and His Creation; the state of harmonious union with God which is the spiritual goal of all men and women. Recalling the original Paradise of Eden, described in Genesis 1 and 2, it is often depicted as a garden. At the centre of the Garden of Eden stand the Tree of Life and the Tree of the Knowledge of Good and Evil. In eating the Forbidden Fruit of the latter man is cast out into the world. Deprived of his original paradisic state man's hope of salvation lies in

his redemption through Christ and the Resurrection, 'To him who conquers I will grant to eat of the tree of life, which is in the paradise of God.' (Rev. 2:7). The New Paradise is the New Jerusalem or Heavenly City described in Revelation 21–22:5. (See City; Garden).

Peacock: Because of its supposedly incorruptible flesh the peacock is a symbol of immortality and the Resurrection.

Pearl: The 'pearl of great price' symbolises true 'gnosis' or knowledge: 'The kingdom of heaven is like a merchant in search of fine pearls, who, on finding one pearl of great value, went and sold all that he had and bought it.' (Matt. 13:45–46). Such knowledge is not to be dispensed lightly, nor is it acceptable to everyone: 'Do not give dogs what is holy; and do not throw your pearls before swine, lest they trample them under foot and turn to attack you.' (Matt. 7:6). The pearl, concealed beneath the waters of the deep, is made available to man as he emerges from the waters, reborn through the rite of baptism. (See Water).

Pelican: According to legend the pelican tears open its breast in order to feed its young with its own blood. It therefore symbolises the sacrifice of Christ on the Cross and the shedding of his blood for the Redemption of man.

Pharisees: The Pharisees (Hebrew 'the separate ones') were one of the Jewish religious parties. They believed in the resurrection (Acts 23:8) and were strict upholders of the law (the Torah). Jesus' critical references to them in the Gospels are aimed at their elitism, hypocrisy, and narrow-minded literalism. They can be taken to represent those whose attitude is governed by these characteristics. (See Sadducees).

Phoenix: At the approach of death, the legendary phoenix makes its own pyre which is lit by the rays of the sun. It burns to ashes in the flames, from which arises another phoenix. The

death and rebirth of the phoenix symbolises the Death and Resurrection of Christ. It also symbolises immortality and the triumph of eternal life over death.

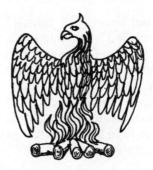

Figure 20. Phoenix

Pilgrimage The pilgrimage presents a symbolic correspondence between man's outer and inner, or physical and spiritual, life. It is the journey through life which, by conscious decision and action, man can direct towards an existing but invisible goal. (See Labyrinth).

Pillar: In many traditions the pillar symbolises the world axis or cosmic tree which simultaneously unites and separates heaven and earth. When the Israelites left Egypt to go to the Promised Land, '. . . the Lord went before them by day in a pillar of cloud to lead them along the way, and by night in a pillar of fire to give them light, that they might travel by day and by night.' (Ex. 13:21–22). 'He who conquers, I will make him a pillar in the temple of my God; never shall he go out of it.' (Rev. 3:12). Solomon erected two bronze pillars, Jachin and Boaz, at the entrance to the vestibule of the Temple (1 Kings 7:15–22). Two pillars marking the entrance or gateway to a sanctuary represent a state of duality which is resolved by the pathway between them leading to a new life.

Plough: The earth is the receptive, female principle and the plough correspondingly represents the active, male principle. Ploughing, through the breaking up of the earth in preparation

107

for the sowing of the seed, unites the two principles in a common purpose and therefore symbolises the union of these two outwardly apparent opposites. (See Sword).

Pomegranate: One of the fruits of the Promised Land, 'For the Lord your God is bringing you into a good land . . . a land of wheat and barley, of vines and fig trees and pomegranates . . .' (Deut. 8:7–8). It represents multiplicity in unity as the Church, with the seeds as its many members. In classical mythology Pluto persuades Proserpine to eat a pomegranate seed so that she will return to him for one third of the year. Her return from the underworld in the spring to regenerate the earth has linked the pomegranate to the Resurrection.

Promised land: Synonymous with heaven and Paradise. It is Canaan, the land promised by God to the Israelites after their wanderings in the wilderness following the Exodus from Egypt. It is the 'land flowing with milk and honey', a land 'in which you will lack nothing.' (Deut. 8:7–10; 27:3). The two principal foods of the Promised Land, milk and honey, are naturally produced foods. Their symbolic value becomes apparent when they are compared with other foods: they need no sowing or reaping; they require no killing (sacrificial or otherwise) as is the case with fish or lamb; they do not need to undergo a process of transformation, such as baking or fermentation, like bread or wine. ✓

Rainbow: A bridge between heaven and earth, and a symbol of reconciliation between God and man. As God said to Noah, 'I set my bow in the cloud, and it shall be a sign of the covenant between me and the earth.' (Gen. 9:13) ✓

Right and left: Right and left represent two opposing poles or principles. Right is the active, masculine, solar, light-giving, heavenly principle. It corresponds to the rational, analytical

function of the human brain (left hemisphere). Left is the receptive, feminine, lunar, dark, earthly principle, corresponding to the intuitive, holistic function of the brain (right hemisphere). The terms masculine and feminine should not be understood as referring exclusively to the male and female sexes. Both male and female each contain the masculine and feminine principles and are sometimes symbolically portrayed together, as a couple, to represent this. (See Man; Marriage; Woman).

Ritual: A ritual is the ceremonial re-enactment, or acting out, usually in the form of a liturgical celebration, of profound religious mysteries. It is a visible sign of the invisible but active relationship between God and man. The daily canon of services and the annual cycle of the Christian year celebrate the continuing presence of Christ in the world.

River: The moving waters of the river signify the perpetual flux of the created world. The river also represents the waters of life. In the Old Testament there is a symbolic diptych in which the waters of Egypt (the material world) cease to give life so that those chosen by God may receive the true waters of life (the Grace or Spirit of God). Moses, following the command of God, strikes the Nile, the river of Egypt, with his rod, 'And the fish in the Nile died; and the Nile became foul, so that the Egyptians could not drink water from the Nile.' (Ex. 7:21). After the Exodus from Egypt God commands Moses to 'take in your hand the rod with which you struck the Nile . . . and you shall strike the rock, and water shall come out of it, that the people may drink.' (Ex. 17:5–6). In Ezekiel the sacred river flows out of the temple 'And wherever the river goes every living creature which swarms will live, and there will be very many fish; for this water goes there, that the waters of the sea may become fresh; so everything will live where the river goes.' (Ez. 47:9). In Revelation it is 'the river of the water of life, bright as crystal, flowing from the throne of God and of the Lamb.' (Rev. 22:1). The Four Rivers of Paradise flowing out of Eden to the four corners of the world are seen as a type for the four Gospels which spread the news of the coming of Christ. (See Fish; Water).

Robe: The seamless robe or tunic of Christ (John 19:23–24), contrasts with the veil of the temple, torn in two at the moment of his death (Matt. 27:51). It can be interpreted as representing the unity of the 'body' of Christ. (See Veil, Woven Fabric).

Rock: Permanence, stability, and steadfastness of faith. The Gospels use a play on words (Greek: *Petros* = Peter, *Petra* = rock) 'You are Peter, and on this rock I will build my church.' (Matt. 16:18). Rock, as inanimate form, also represents the outer, material solidity which needs to be symbolically broken open for the inner, life-giving spiritual forces to flow – Moses striking the rock which yields water (Ex. 17:6); the piercing of Christ's side from which flows the blood and water of the New Covenant. St Paul links these two images, 'For they drank from the spiritual Rock . . . and the Rock was Christ.' (1 Cor. 10:4) In the Parable of the Sower (Matt. 13:3–23) the 'word of the kingdom' which falls on rocky ground (i.e. is only taken in at a shallow or literal level) quickly withers because it has no root. (See Stone.)

Rod: A symbol of divinely-given power or authority. God changing Moses' rod into a serpent and back again (Ex. 4:2–5) can be interpreted as the dark, negative forces of the world transformed by the Divine Will into a positive power. It is also the *solve et coagula* of alchemy. (See Brazen Serpent; Serpent).

Room: Withdrawal from the world to an inner or higher state. Many fifteenth century Flemish religious paintings illustrate this with a view through a window of a town or landscape. Alternatively, light coming in through the window of a room signifies the penetration of inner darkness. It also signifies receptivity, 'In my Father's house are many rooms.' (John 14:2) or, as with the birth of Jesus, the lack of it, '. . . there was no room for them in the inn.' (Luke 2:7).

Rosary: (Latin *rosarium* = rose garden). The mystic rose garden of the Virgin Mary. The rosary, with 150 small beads

divided into groups of 10 (decades) by 15 larger ones, is used for counting prayers. Each chaplet (one third, or five decades) recalls five of the fifteen Mysteries of the Rosary, episodes from the life of Jesus and the Blessed Virgin Mary. The Joyful Mysteries: Annunciation; Visitation; Nativity; Presentation in the Temple; Finding of Jesus in the Temple. The Sorrowful Mysteries: Agony in the Garden; Scourging of Jesus; Crown of Thorns; Way of the Cross; Crucifixion. The Glorious Mysteries: Resurrection; Ascension; Descent of the Holy Spirit; Assumption and Coronation of the Blessed Virgin Mary. (See Garden).

Rose: The Virgin Mary is the Mystic Rose, the 'Rose of Sharon' (Song 2:1), and the 'Rose without a Thorn' (the perfect rose, free of the thorns (sins) of the Fall). The red rose which reputedly, sprang from the drops of Christ's blood shed on Calvary, represents love and martyrdom.

Ruins: In Christian art ruins are frequently depicted in scenes of the Nativity as a symbol of the Old Covenant (Judaism) out of which comes the foundation or corner stone of the New Covenant (Christ). An alternative interpretation is that the ruins stand for man's 'chaotic' state which is redeemed through the coming of Christ.

Sacrament: A sacred obligation or mystery. Sacraments are outward signs corresponding to the inner action of grace. They mark the key points of man's physical and spiritual life. For the Roman Catholic and Orthodox Churches there are seven: Baptism; Confirmation; Mass or Eucharist; Confession; Holy Orders (for clergy); Matrimony (for lay persons); Extreme Unction. (The two sacraments of the Protestant Churches are Baptism and the Lord's Supper).

Sadducees: One of the two Jewish sects frequently portrayed opposing the teachings of Jesus (the others being the Pharisees). They recognised only the written Law and rejected

the resurrection. Jesus says to them, 'You know neither the scriptures nor the power of God.' (Matt. 22:29). They represent ignorance, an obstacle to the acceptance of Christ, brought about through resistance to change.

Salt: Salt symbolised the making of a bond or covenant, 'it is a covenant of salt for ever before the Lord for you and for your offspring with you.' (Numbers 18:19). It also represents the faith, spiritual understanding, or obedience which is man's part of the covenant with God. 'You are the salt of the earth; but if the salt has lost its taste, how shall its saltness be restored?' (Matt. 5:13).

Sea: The primordial waters, or the waters of life, which are safely crossed with guidance from God but engulf those who ignore the Divine Purpose, e.g. The Flood and Noah's ark; the waters of the Red Sea dividing to allow the Israelites to cross and then returning to drown the Egyptian armies (Exodus 14:16–31). (See Ship, Water).

Seed: The Kingdom of Heaven. The Word or Will of God and its manifestation in mankind, or man. Jesus' first parable is the Parable of the Sower, 'As for what was sown on good soil, this is he who hears the word and understands it.' (Matt. 13:23). It is followed by the Parable of the Mustard Seed, 'The kingdom of heaven is like a grain of mustard seed . . . the smallest of all seeds, but when it has grown it . . . becomes a tree,' (the Tree of Life). In order for seed to bear fruit it has to die. It has to die to what it was in order to be transformed into the potential life it contains: 'What you sow does not come to life unless it dies . . . What is sown is perishable, it is raised imperishable . . . It is sown a physical body, it is raised a spiritual body. If there is a physical body, there is also a spiritual body.' (1 Cor. 15:36–44)

Serpent: An ambivalent symbol. Because of the Temptation and Fall the serpent is synonymous with Satan, evil, and the dark, formless forces active in the world. It symbolises

deception and it could be said that the serpent represents all
that appears to separate man from God. 'That ancient serpent,

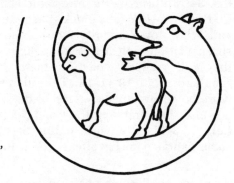

Figure 21.
Serpent and the Lamb,
from a 12th century
Italian crozier

who is called the Devil and Satan, the deceiver of the whole
world.' (Rev. 12:9). The serpent, and what it represents, is
rendered harmless by the intervention of God's Will and by
man's reciprocal faith in the divine purpose, 'Every one who
asks receives ... What man of you, if his son asks ... for a
fish, will give him a serpent? ... How much more will your
Father who is in heaven give good things to those who ask him!'
(Matt. 7:8–11). 'Those who believe ... will pick up serpents.'
(Mark 16:17–18). (See Brazen Serpent, Dragon, Fall, Rod).

Figure 22. *Scallop shell*

Shells: The scallop shell became the emblem of pilgrims to
the shrine of St James the Greater at Santiago de Compostella,
and subsequently of pilgrims in general. The stoup, a container
for Holy Water placed near the entrance of a church, is often in
the form of a shell or shell-shaped stone.

Shepherd: God's spiritual guidance of his flock (mankind) of sheep (man). 'I myself will be the shepherd of my sheep.' (Ez. 34:15). Jesus is the Messianic shepherd who will unite God's sheep into one flock, 'I am the good shepherd; . . . and I lay down my life for the sheep. And I have other sheep that are not of this fold; I must bring them also, and they will heed my voice. So there shall be one flock, one shepherd.' (John 10:14–16). The 'other sheep' are the Gentiles, represented by the shepherds of the Nativity (Luke 2:8–20). See also the Parable of the Good Shepherd (Matt. 18:10–14; Luke 15:3–7). It is worth noting that 'every shepherd is an abomination to the Egyptians.' (Gen. 46:34). (See Egypt).

Ship: In the Gospels boats are much in evidence, crossing back and forth across the Sea of Galilee. A boat or ship is a symbolic vessel for safely sailing over the sea or waters of life. It rises above or transcends the pull of the material world and man's lower nature. It also represents the spiritual guidance and faith that enables this to be done. Jesus, as Saviour, is able to walk over the water, whereas Peter, lacking sufficient faith, sinks. (Matt. 14:22–23). The 'Ship of Salvation' is variously represented as Noah's ark surviving the Flood (Genesis 6:13–8:19); the Ark of the Covenant (especially with regard to the miraculous crossing of the River Jordan (Josh. 3:11–17).); and the Church. The nave, the central aisle of a church building, reputedly takes its name from the Latin *navis*, meaning ship. (See Sea, Water; also Chapter 5, Peter).

Ship of fools: A late medieval theme, symbolising the antithesis of the Ship of Salvation, in which a shipload of fools set sail for the 'fool's paradise'. It satirises the weaknesses and follies of human nature.

Shoes: Man's worldly nature. 'Put off your shoes from your feet, for the place on which you are standing is holy ground.' (Ex. 3:5). In some traditions taking off one's shoes to enter a room, whether done on an inner or outer level, symbolises the leaving behind of worldly contact.

Skull: The mortality of man's physical body. According to legend, Golgotha, the Place of the Skull, is where Adam's skull was buried. (See Chapter 4, 'The Legend of the True Cross').

Soul: In medieval iconography the soul is often represented as a young child, either emerging from the mouth of a dead or dying person, or placed in the lap of Abraham.

Stairs/steps: Signify ascension, in the material or spiritual sense, from one level to another. For this reason a place of worship, or an area within it such as the chancel, is often raised above the level of the ground and reached by ascending a flight of steps. Stairs and steps share the symbolism of the ladder.

Star: Symbol related to the Divine Light. The star of the Nativity heralds the birth of Christ, the Light of the World. The light of the star shining in the night represents the light of the spirit penetrating the darkness. Christ is 'the bright morning star.' (Rev. 22:16). The Virgin Mary, as Queen of Heaven, is portrayed wearing a crown of stars.

Stone: An ambivalent symbol. Stone, like rock, as solid and inanimate matter, represents the stability of a sure foundation. Jesus is 'the very stone which the builders rejected' that becomes 'the head of the corner.' (Mark 12:10) 'This is the stone which was rejected by you builders . . . and there is salvation in no one else.' (Acts 4:11–12). Stone can also be taken to signify an initial level of understanding of Christ's message, built on faith. For the faithful Christian Christ becomes the 'bread of life', providing him with the food which stone cannot give, 'What man of you, if his son asks him for bread will give him a stone?'(Matt. 7:9). (See Rock; also Chapter 6, 'The Marriage at Cana').

Sun: God's radiant splendour; the Divine Light. Christ 'the sun of righteousness [who] shall rise, with healing in its wings.'

(Mal. 4:2). It is the active, masculine principle (light, fire, spirit and heaven) as opposed to the moon, the receptive, feminine principle (darkness, water, matter and earth).

Sword: Power and authority. 'The sword of the Spirit, which is the word of God.' (Eph. 6:17). 'The word of God' is also 'living and active, sharper than any two-edged sword, piercing to the division of soul and spirit.' (Heb. 4:12). As an instrument of war its violence contrasts with the more peaceable action of the plough. 'Prepare war . . . beat your plowshares into swords . . . let the weak say, "I am a warrior."' (Joel 3:9–10). 'And they shall beat their swords into plowshares . . . neither shall they learn war any more.' (Isaiah 2:4). (See Plough). The sword is also linked by its shape to the Cross.

Temple: A universal and complex symbol, representing simultaneously the macrocosm and the microcosm. It is the dwelling place of God on earth, 'the House of God', a meeting-place for God and man, heaven and earth. The Temple at Jerusalem, scene of 'the Cleansing of the Temple' (John 2:13–17) was the national shrine of the Jews. The New Covenant or new relationship between man and God, revealed by Jesus, provides a new image of the temple: '"Destroy this temple and in three days I will raise it up" . . . but he spoke of the temple of his body.' (John 2:19–21). 'Do you not know that you are God's temple, and that God's Spirit dwells in you?' (1 Cor. 3:16) In Christianity the church or cathedral fulfils the function of the temple building as a place of communal worship.

Thistle/Thorn: They both represent suffering, pain, grief, and sorrow, the harvest of man's transgression of God's commandment: 'Cursed is the ground because of you . . . thorns and thistles it shall bring forth to you.' (Gen. 3:17–18). In the Parable of the Sower 'What was sown among thorns . . . is he who hears the word, but the cares of the world and the

delight in riches chokes the word, and it proves unfruitful.' (Matt. 13:22). The Crown of Thorns, one of the symbols of Christ's Passion, signifies 'the sins of the world' which he redeemed through his Death and Resurrection.

Throne: The seat of highest authority. God's Kingship over the world, 'Heaven is my throne, and earth my footstool.' (Isaiah 66:1; Acts 7:49). The throne of God's Kingship is the source of life in the Heavenly City, 'The river of the water of life, bright as crystal, flowing from the throne of God and of the Lamb.' (Rev. 22:1). In medieval iconography the 'Madonna and Child Enthroned' was a popular image, its raised throne signifying the beginning of a new reign on earth.

Tower: Like the mountain it reaches heavenwards, signifying spiritual elevation or ascent. It shares the symbolism of the ladder and pillar as a link between heaven and earth. The ivory tower is a symbol of the Virgin Mary (Song 7:4). The Tower of Babel, built by 'the people of the plain', represents man's attempt to raise himself up by his own devices or create his own image of heaven, without God's help: 'Come, let us build ourselves a city, and a tower with its top in the heavens.' (Gen. 11:4). The attempt results in confusion.

Tree: Universal and complex symbol. It is a living counterpart to the ladder and pillar, symbolic links between heaven and earth. Among the trees in the Garden of Eden are 'the Tree of the Knowledge of Good and Evil' and 'the Tree of Life' (Gen. 2:9). The former bears bad fruit, the Fruit of the Fall, cause of man's expulsion from Paradise; the latter bears good fruit, the Fruit of Eternal Life. The Tree of Life is echoed in the 'tree' of the Cross, and in Christ, 'the True Vine', who provides the living link between heaven and earth (see Vine). As a symbolic image it is sometimes used as an allegory for man. 'Blessed is the man who trusts in the Lord, whose trust is the Lord. He is like a tree planted by water, that sends out its roots by the stream . . .' (Jer.17:7–8). (See also the parables and miracles involving fig trees.); and enigmatically, 'I see men; but they look like trees,

walking.' (Mark 8:24). Its three main division (roots, trunk, branches) correspond to the tripartite division of man (body, mind, spirit), and both are valued according to the fruit they produce, 'Beware of false prophets ... You will know them by their fruits ... every sound tree bears good fruit, but the bad tree bears evil fruit.' (Matt. 7:15–17). The 'Tree of Jesse', a frequently occuring image in medieval religious art, illustrates Isaiah's prophecy regarding the messianic king, 'There shall come forth a shoot from the stump of Jesse, and a branch shall grow out of his roots.' It traces Jesus' ancestors back to Jesse's son, David, a prefigurative type of Christ.

Unicorn: Mythical animal symbolising chastity and purity. Its single horn, signifying unity, purifies whatever it touches. The unicorn is pursued in vain by hunters but may be captured by a virgin, in whose lap it finds rest. The story of 'The Lady and the Unicorn' became an allegory for the Incarnation of Christ, the spiritual unicorn and 'a horn of salvation for us.' (Luke 1:69).

Vase: The lily standing in a vase filled with water is frequently present in scenes of the Annunciation. It represents the order established over the unformed chaos of the waters of the deep by the Spirit of God and the Incarnation of the Word. (See Water).

Veil: The veil, like the screen or curtain, unites the dual function of concealment and revelation. It also fulfils a protective purpose in shielding man from the full radiance of God's Glory. In the Tabernacle the Ark of the Covenant was placed behind a veil, 'And the veil shall separate for you the holy place from the most holy.' (Ex. 26:33). The rood screen and the *iconostasis* which separate the sanctuary from the main body of the church fulfil a similar function. Moses, coming down from Mount Sinai, 'did not know that

the skin of his face shone because he had been talking to God ... and they were afraid to come near him ... when Moses had finished speaking with them, he put a veil on his face.' (Ex. 34:29–35). The veil signifies the mystery of God which can only be revealed to man through His Will. 'And he will destroy on this mountain the covering that is cast over all peoples, the veil that is spread over all nations.' (Isaiah 25:7). 'Only through Christ is it [the veil] taken away.' (2 Cor. 3:14).

Vesica piscis: The *vesica piscis*, also know as the *mandorla*, is the elongated almond-shape formed by the intersection of two circles. It symbolises the interaction or interdependence of opposing worlds or forces. The circles may be taken to represent spirit and matter or heaven and earth. In this case the *vesica piscis* symbolises their meeting point. In Christian iconography it appears as the aureole enclosing the figures of the Virgin and Child or Christ.

Vine/vineyard: The symbolic vine and vineyard are very close to each other and to the symbolism of grapes and wine. The Old Testament vine or vineyard is Israel, 'Thou didst bring a vine out of Egypt.' (Psalms 80:8); 'The vineyard of the Lord of Hosts is Israel.' (Isaiah 5:7). With the devastation of Israel 'the vine withers.' (Joel 1:12). The New Testament vine is Christ, 'I am the true vine, and my Father is the vinedresser ... you are the branches' (John 15:1–5). The Parable of the Vineyard (Matt. 21:33–46), although appearing to have specific relevance for 'the chief priests and Pharisees', may be interpreted, like the Labourers in the Vineyard (Matt. 20:1–16), as expressing the living relationship between God and man and is thus eternally relevant. (See Grapes, Tree, Wine).

Water: The source of life – a universal and complex symbol. The primordial waters or 'waters of the deep' symbolise the darkened, formless chaos which was given form by the Spirit

119

of God. 'The earth was without form and void, and darkness was upon the face of the deep; and the Spirit of God was moving over the face of the waters.' (Gen. 1:2). As God's Spirit is continually present in the world the Creation may be interpreted as the continual flux of manifestation. The individual seeks to emerge from this chaotic darkness in order for his own life to be given form and meaning through God's Grace and Spirit. In medieval iconography the symbolic waters are inhabited by malevolent and benevolent life forms – voracious sea monsters and fish (see Fish). The sea monsters (like the Dragon or Serpent) represent the dark or 'evil' forces which may drag man back towards chaos, away from the Spirit which has given him form and life. The fish symbolise man in his 'fallen' state awaiting the net of salvation (see Net). The surface of the waters is the sea of life across which man navigates his way once he has emerged from the deep (see Sea; Ship). The account of Jonah being cast from a ship back into the deep and swallowed by 'a great fish', from the belly of which he prays to the Lord for deliverance before being 'vomited out . . . upon the dry land,' illustrates the redemptive power of the Spirit: initially Jonah had boarded the ship 'to go . . . away from the presence of the Lord,' (Jonah 1–2). In baptism by total immersion the Christian is plunged back into the waters to re-emerge, purified and reborn in the name of Christ, through water and the Spirit. For man Christ is the 'fountain of living waters' (Jer. 2:13; see Fountain), the 'water welling up to eternal life'. (John 4:10–14; see Well). Water, as a source of life, also signifies an inner or higher truth, other than the outer literal understanding represented by stone. 'You shall bring water out of the rock for them; so you shall give drink to the congregation,' (Num. 20:8). The mixture of water and wine, Christ's blood of the Eucharist, may be taken to represent the invisible union of humanity and the divine Spirit in Christ. It is the blood of the New Covenant, 'poured out for many' (Mark 14:24), which brings about man's reconciliation with God: '. . . strangers to the covenants of promise, having no hope and without God in the world. But now in Christ Jesus you who were once far off have been brought near in the blood of Christ.' (Eph. 2:12–13). In both the Old and New Testaments there are many events or miracles involving water which serve to reveal God's invisible

and mysterious presence at work in the world. These include the Flood (Gen. 6–9); the Crossing of the Red Sea (Ex. 14:21–31); the water from the rock (Ex. 17:1–7; Num. 20:10–13); the Crossing of the Jordan (Joshua 3–4); Gideon's Fleece (Judges 6:36–40); Jonah and the whale (Jonah 1–2); the wedding at Cana: water changed to wine (John 2:1–11); Jesus walking on the water (Mark 6:47–51). (See also Chapter 2, 'Water as a symbol of life')

Well: The well, like the oasis in the desert, provides water for the traveller. Christ, the 'living water', gives refreshment to the spiritually thirsty. When he encounters the Samaritan woman beside Jacob's well, Jesus says to her, 'Every one who drinks of this water will thirst again, but whoever drinks of the water that I shall give him will never thirst; the water that I shall give him will become a spring of water welling up to eternal life.' (John 4:7–15).

Whale: The whale is the 'great fish' which swallowed up Jonah and held him for 'three days and three nights' before vomiting him up out onto dry land. (Jonah 1:17–2:10). As Jonah is a type for Christ, the whale represents the tomb from which man may emerge, having overcome death, to gain eternal life. The darkness of the tomb or cave signifies the unlit darkness of man's death in sin – his apparent separation from God. In medieval Christian iconography the mouth of the whale represents the jaws or gates of Hell while its belly is Hell itself.

Wheel: The wheel is a symbol of the sun and the cycle or cycles of time. It symbolises the universe and the whole of creation. The wheel combines movement with stillness: the rotation of the spokes and outer rim around a stable axis. The spokes of the wheel link the central axis to the rim and represent the apparent division of the One into the many: the Creator and the multiplicity of the created world. These apparent divisions, however, remain contained within the wholeness or unity of the outer circumference of the wheel's rim. It signifies the created or manifest world which while dependent on its Creator (the

central axis) appears to revolve independently around it. As the wheel travels along a horizontal plane the meeting-point of the two (i.e. the circular rim of the wheel and the straight line of the horizontal plane) is the 'point' at which the world as we know it comes into being – the point at which time and space emanating from the central axis unfold themselves into the linear time and space of the created world. (This process of unfoldment is represented diagramatically by the spiral.) This point, though, is not confined by linear time and space. It is the 'wheel within a wheel,' beneath God's throne (Ez. 1:16). The potter working at his wheel is an allegory of God's continually active presence in the created world, 'Can I not do with you as this potter has done? . . . Behold, like the clay in the potter's hand, so are you in my hand.' (Jer. 18:6). The wheel drawing water from the well and the grinding function of the circular millstone are similarly allegorical, providing us with the water and bread of life. The wheel motif, inseparable from that of the circle, occurs frequently in Christian art and symbolism. The 'Chi-rho' monogram forms a six-spoked wheel. The development of the simple circular window into the 'wheel window' and thence into the elaborate symbolism of the great stained-glass rose windows of the French Gothic cathedrals is a subject for study in its own right.

Figure 23. Wheel of Fortune.
French, 13th century (after
Villard de Honnecourt)

Wheel of fortune: Medieval symbol of the instability of human existence referred to in Boethius' *Consolation of Philosophy*. Like the wheel, it represents the cyclical nature of time. The small figures depicted either clutching to its rim or falling off it may be taken to signify the paradoxical situation

of man's raising himself up leading to his fall, or man's fall leading to him being raised up. 'Whoever seeks to gain his life will lose it, but whoever loses his life will preserve it.' (Luke 17:33)

Wilderness: A barren and desolate place symbolising a stage in man's wandering search for God. The Israelites are guided through it in their journey from 'Egypt' to the Promised Land'. John the Baptist, announcing the coming of Christ, is 'the voice of one crying in the wilderness.' (John 1:23; also Isaiah 40:3).

Window: 'The eyes are the window of the soul.' The window is inseparable from the symbolism of light. As a barrier between interior and exterior it has a dual function, allowing one to see out and, at the same time, allowing light in to penetrate inner darkness. The opening of a window symbolises the removal of this barrier that separates the inner from the outer world, and the opening of the heart or soul to receive the Spirit. The Flood, which brings about Noah's new life and covenant with God, is preceded by the words 'On that day all the fountains of the great deep burst forth, and the windows of heaven were opened.' (Gen. 7:11). In church architecture a number of windows grouped together, or the number of divisions in a window, may also have some symbolic significance (see Appendix). The Gothic rose window is linked to the symbolism of the circle and the wheel.

Wine: The fermented fruit of the vine. Wine, like bread, is produced by a process of transformation involving yeast (see Bread; Leaven). The bread and wine of the Eucharist, the flesh and blood of the body of Christ, signify his humanity and divinity. They provide the material and spiritual food necessary for sustaining the Christian's life in Christ. 'He who eats my flesh and drinks my blood abides in me, and I in him.' (John 6:56). The human and divine nature of Christ are also present in the water and wine poured together into the chalice to become the blood of the True Vine,

the redemptive blood of Christ (see Water). Wine, because of its intoxicating effect, is associated with the Holy Spirit. At Pentecost, after the descent of the Spirit, the Apostles are mocked by some as being 'filled with new wine,' (Acts 2:13). The new wine, the Spirit of the New Covenant, brings with it a new understanding which supersedes the old, 'No one puts new wine into old wineskins; if he does, the wine will burst the skins, and the wine is lost, and so are the skins; but new wine is for new skins.' (Mark 2:22) (See Chapter 6, 'The Marriage at Cana'). Wine is also the judgement or wrath of God, 'If any one worships the beast . . . he also shall drink the wine of God's wrath, poured unmixed into the cup of his anger.' (Rev. 14:9–10).

Winepress: The winepress symbolises the wrath of God, incurred when man chooses to ignore Him: 'I have trodden the winepress alone, and from the peoples no one was with me; I trod them in my anger and trampled them in my wrath.' (Isaiah 63:3). The redemptive blood of Christ flows from the winepress, revealing to man the magnitude of God's love, 'For God so loved the world that he gave his only Son, that whoever believes in him should not perish but have eternal life.' (John 3:16). It could be said that those who turn from God experience his wrath while those who turn to Him experience his love.

Woman: In symbolic terms 'woman' stands for what is referred to as the feminine principle whereas 'man' represents the masculine (see Right and Left). Woman and man signify apparent opposites which are reconciled through their union or marriage and 'become one flesh'. 'There is neither slave nor free, there is neither male nor female; for you are all one in Christ Jesus.' (Gal. 3:28). In Christian iconography the Church is personified by a woman, either as the Virgin Mary or as 'the bride of Christ'. In a wider symbolic context 'woman' is the Mother Goddess or *prima materia* through which the spirit is given form or flesh. (See Man; Moon; Right and Left).

Word: The Word may be regarded as the self-revelation of God through His active presence in the creation of the world. 'And God said, "Let there be light"; and there was light.' (Gen. 1:3). The profound mystery of the Incarnation of the Word is expressed in the opening chapter of the Fourth Gospel (John 1:1–18).

Woven fabric: The symbolism of woven fabric is universal and includes all kinds of garments, veils, curtains, etc., and may be extended to any material which performs the function of wrapping or concealing. Its symbolic interpretation stems from the ancient idea which saw the creator of the universe as a weaver and the created world as the garment he wove to clothe himself. The fabric consists of horizontal and vertical threads – the weft and warp. The weft represents the horizontal or linear plane of the material world. It is *materia prima*, the form of which is determined by the transcendent Spirit represented in the vertical threads of the warp. This symbolic union of the material and transcendent is present throughout the whole fabric, and at each point where the threads meet in the form of a cross. (See Garments; Net; Veil).

Zodiac: The symbolism of the Zodiac is extensive and complex. In very simple terms it expresses the relationship between the invisible forces at work in the universe and the visible world. It is usually represented in the form of a wheel divided into twelve segments (see Appendix: 'Twelve'). Christian iconography in medieval Europe linked the twelve signs of the Zodiac with the annual cycle of man's labour.

The following books proved invaluable in compiling the Glossary and are recommended to those interested in exploring symbols further.
Church, Monastery, Cathedral, H. Whone, (Element Books, 1977. New edition due 1990).

A Dictionary of Symbols, J.E. Cirlot. Tr. Jack Sage. (Routledge & Kegan Paul, London, 1962).

Dictionary of Christian Lore and Legend, J.C.J. Metford, (Thames and Hudson, London, 1983).

Dictionary of Subjects and Symbols in Art, J. Hall, (John Murray, London, 1984).

An Illustrated Encyclopaedia of Traditional Symbols, J.C. Cooper, (Thames and Hudson, London, 1978).

APPENDIX: NUMERICAL SYMBOLISM

The following is a brief list of the principal symbolic numbers with examples of the forces they represent and, where applicable, their occurence. Traditionally the principal numbers are 1 to 10 because they contain all numbers. Further numbers (i.e. additions and multiples of 1 to 10) represent the interaction of these forces. (For a fuller background explanation to numerical symbolism, see Chapter 3).

ONE: God; oneness; unity.

TWO: The division of unity; duality; opposite poles – left/right, sun/moon, masculine/feminine, etc. The dual nature (human and divine) of Christ.

THREE: The combined total of the first two numbers: 1+2=3. The number three progresses beyond duality into what is referred to as 'the law of three'. That is, the threefold nature which appears to govern the existence of things. (This is most obvious in the Trinity or triunity of God.) It represents the fullness of created things or what is referred to as 'multiplicity': the interaction between 1 and 2 having overcome duality. The three-fold nature or levels of man's whole being – body, mind or soul, spirit (lower or animal, human, and spiritual or higher) and his fulfilment or totality. The soul. The spirit and/or spiritual

things. It is a number which frequently occurs in the Gospels at the beginning of a passage: 'On the third day . . .', signifying the profound levels of meaning in what follows, extending beyond the outer or literal level. It is also encountered in the three temptations of Christ, the three denials of Peter, the three days of the Death and Resurrection of Christ.

FOUR: The earth; matter and/or material things; the body; wholeness. The created world. The four Evangelists; the four Rivers of Paradise; the four Worlds or Kingdoms; the four Continents; the four corners of the world; the four elements; the four seasons.

FIVE: The human microcosm; the number of man; the five senses; the five Wounds of Christ.

SIX: The six days of the Creation; the number of preparation and/or completion. Perfection, as expressed in the total sum of the first three numbers: $1+2+3=6$.

SEVEN: 3 (soul/spirit) + 4 (body/matter) = completeness – the union of the dual natures of man and the spiritualisation of the body. The Seven Ages of man; the Seven Vices and Seven Virtues; the Seven Sorrows and Seven Joys of the Virgin Mary; the seven planets governing human destiny; the seven tones of music; the seven days of the week. The Seven Heavens.

EIGHT: The octave = rebirth. The Resurrection, because Christ rose on the eighth day after entering Jerusalem. The eighth day of circumcision. The spiritual goal achieved after passing through the seven stages or heavens. The eight Beatitudes. Baptismal fonts are frequently eight-sided, symbolising re-birth.

NINE: The Triple Triad. Completion – nine months from conception to birth. Nine choirs of angels. Nine fruits of the Holy Spirit.

TEN: The perfect number which, containing all other numbers, contains all possibilities. The Ten Commandments; the ten virgins and their lamps.

TWELVE: $3 \times 4 = 12 =$ the infusion of matter (4) with spirit (3). The twelve prophets and the twelve disciples = the spreading of the spiritual word in the material world. The twelve months of the year. The twelve signs of the Zodiac.

FIFTEEN: The number of groups of beads (ten in each group) in the rosary and the number of steps the Virgin Mary ascended when she entered the Temple on leaving her parents. Progress.

FORTY: Period of trial and probation or return. The number of days it rained prior to the Flood. The number of days of Christ's temptation, of Lent, and between Easter and Ascension.

GEOMETRIC FIGURES AND FORMS

The symbolic use of geometric figures is encountered in sacred geometry, frequently playing an integral part in the design and decoration of sacred architecture. These figures are sometimes two-dimensional, as, for example, in the plan or elevation of a building, and sometimes three-dimensional, as in the internal or external form of an edifice.

The circle is particularly important. As a geometric figure without beginning or end it symbolises the unique and infinite wholeness of God. According to the alchemist, Hermes Trismegistus, 'God is a circle whose centre is everywhere and circumference is nowhere.'

Many-sided figures such as the triangle, square, pentagon, hexagon, octagon, etc., are frequently geometric projections of numbers and therefore share the same symbolic interpretations (e.g. triangle (3) = the Trinity; square (4) = earth; octagon (8) = rebirth). The same principle may also apply to geometric solids such as the sphere, pyramid, cube, etc.

BIBLIOGRAPHY

Sources and suggestions for further reading:

du Bourguet, Pierre. '*La Peinture Palèo-Chrétienne*', Editions Robert Laffont, Paris, 1965.

Bridge, A. C. '*Images of God (An Essay on the Life and Death of Symbols)*', Hodder and Stoughton, London, 1960.

Brooke, Rosalind and Christopher. '*Popular Religion in the Middle Ages*', Thames and Hudson, London, 1984.

Burckhardt, Titus. '*Alchemy*', trans. William Stoddart, Element Books, Shaftesbury, 1986.

Burckhardt, Titus. '*Sacred Art in East and West*', trans. Lord Northbourne, Perennial Books, Bedfont, 1986.

Cirlot, J. E. '*A Dictionary of Symbols*', trans. Jack Sage, Routledge and Kegan Paul, London, 1962.

Cook, Roger. '*The Tree of Life (Image for the Cosmos)*', Thames and Hudson, London, 1974.

Coomaraswamy, Ananda K. '*Christian and Oriental Philosophy of Art*', Dover Publications, New York, 1954.

Cooper, J. C. '*An Illustrated Encyclopaedia of Traditional Symbols*', Thames and Hudson, London, 1978.

Cowen, Painton '*Rose Windows*', Thames and Hudson, London, 1979.

Dillenberger, Jane. '*Style and Content in Christian Art*', SCM Press, London, 1986.

Dillistone, F. W. '*Christianity and Symbolism*', SCM Press, London, 1985.

Every, George. '*Christian Mythology*', Hamlyn, Twickenham, 1987.

Gilmore Holt, E. 'A Documentary History of Art, Volume 1', Doubleday Anchor, New York, 1957.

'Gospel of Thomas', presented by Hugh McGregor Ross, William Sessions, York, 1987.

Griffiths, Bede. 'The Marriage of East and West', Collins Fount, London, 1983.

Hall, J. 'Dictionary of Subjects and Symbols in Art', John Murray, London, 1984.

Hooke, S. H. 'Middle Eastern Mythology', Penguin Books, Harmondsworth, 1963.

Inge, W. R. 'Mysticism in Religion', Hutchinson, London, 1947.

Jung, Carl. (ed.) 'Man and His Symbols', Pan/Picador, London, 1978.

a Kempis, Thomas. 'The Imitation of Christ', trans. Leo Sherley-Price, Penguin, Harmondsworth, 1952.

Kitto, H. 'The Greeks', Penguin Books, Harmondsworth, 1951.

Male, Emile. 'The Gothic Image (Religious Art in France of the Thirteenth Century)', trans. Dora Nussey, Collins/Fontana, London, 1961.

Metford, J. C. J. 'Dictionary of Christian Lore and Legend', Thames and Hudson, London, 1983.

Needleman, Jacob. 'Lost Christianity (A Journey of Rediscovery to the Centre of Christian Experience)', Element Books, Shaftesbury, 1990.

New Catechism (The Catholic Faith for Adults)', Search Press, Tunbridge Wells, 1967.

Nichols Jr., Stephen G. 'Romanesque Signs (Early Medieval Narrative and Iconography)', Yale University Press, New Haven and London, 1983.

Nicoll, Maurice, 'The Mark', Shambhala, Boston and London, 1985.

Nicoll, Maurice. 'The New Man', Shambhala, Boulder and London, 1984.

Origen. Trans. Rowan A. Greer, Paulist Press, New York, 1979.

Pennick, Nigel. 'The Ancient Science of Geomancy', Thames and Hudson, London, 1979.

Pagels, Elaine. 'The Gnostic Gospels', Penguin Books, Harmondsworth, 1982.

Robinson, Edward. 'The Language of Mystery', SCM Press, London, 1987.

Rolle, Richard. 'The Fire of Love', trans. Clifton Walters, Penguin Books, Harmondsworth, 1972.

Runciman, Steven. 'Byzantine Style and Civilisation', Penguin Books, Harmondsworth, 1975.

Simcox Lea, T. and Bligh Bond, F. 'The Apostolic Gnosis', Research into Lost Knowledge Organization, London, 1979.

von Simson, 'The Gothic Cathedral (Origins of Gothic Architecture and the Medieval Concept of Order)', Princeton University Press, Princeton and London, 1974.

Suares, C. 'The Cipher of Genesis', Stuart and Watkins, London, 1970.

'Theologica Germanica', trans. Susanna Winkworth, Stuart and Watkins, London, 1966.

Thurian, Max. 'Mary, Mother of the Lord, Figure of the Church', trans. Neville B. Cryer, Mowbray, Oxford, 1985.

Warner, Marina. 'Alone of All Her Sex (The Myth and Cult of the Virgin Mary)', Pan Books, London, 1985.

Watts, Alan. 'Behold the Spirit (A Study in the Necessity of Mystical Religion)', Random House/Vintage Books, New York, 1972.

Watts, Alan. 'Myth and Ritual in Christianity', Beacon Press, Boston, 1968.

Whone, H. 'Church, Monastery, Cathedral', Element Books, Shaftesbury, 1977.

INDEX